HOCKEY IN THE
CAPITAL DISTRICT

HOCKEY IN THE CAPITAL DISTRICT

Jim Mancuso

ARCADIA
PUBLISHING

Published by Arcadia Publishing
Charleston, South Carolina

Printed in the United States of America

Library of Congress Catalog Card Number: 2006923085

For all general information contact Arcadia Publishing at:
Telephone 843-853-2070
Fax 843-853-0044
E-mail sales@arcadiapublishing.com
For customer service and orders:
Toll-Free 1-888-313-2665

Visit us on the Internet at www.arcadiapublishing.com

In memory of Bill Moe, player-coach of the Troy

Uncle Sam's Trojans and the first player of a Capital District

team inducted into the United States Hockey Hall of Fame.

CONTENTS

ACKNOWLEDGMENTS

The images in this book are courtesy of Ernie Fitzsimmons, Rensselaer Polytechnic Institute (RPI), and the Albany River Rats hockey club. Though the photographs were not obtained from them directly, credit is due to the following photographers, who were responsible for actually taking some of the photographs featured in this publication: James S. Carras, Kevin Cleveland, Thomas Donnelly, Lisa Meyer, Martin Oravec, Steve Twarizik, and John M. Vollaro.

I would like to thank Ernie Fitzsimmons, Edwin Duane Isenberg, and Kevin Beattie (director of sports information at Rensselaer Polytechnic Institute) for their imaging work on the illustrations in this book.

I was helped directly through the Albany River Rats office by vice president of communications and marketing Jonathan Scherzer and River Rats intern Jeffrey McCann.

The statistics in this book were obtained from the 1956–1957 Eastern Hockey League Yearbook, the 1959–1960 Eastern Hockey League Yearbook, Ralph Slate's Hockey Database (http://www.hockeydb.com), the Society for International Hockey Research, and *Total Hockey: The Official Encyclopedia of the National Hockey League* (NHL) (second edition). Please note: official Eastern Amateur Hockey League (EAHL) annual statistics were not broken up by team for some seasons.

Other resources used to complete this work included *The Clinton Comets: An EHL Dynasty*, by Jim Mancuso and Fred Zalatan; John Brophy; *The Hockey News* (1947–2006); "The Sporting News Hockey Guide" (1982–1983, 1987–1988, and 1991–1992 to 2005–2006); *Schenectady Gazette*, Schenectady, New York (1981), *Times Union*, Albany, New York (1990–1991 and 1993–2006); *Troy Record*, Troy, New York (1950–1953 and 1990–1993); Uncle Sam's Place Web site (http://www.uncle-sams-home.com); and Fred Zalatan.

A special thanks to my mother, Joan Mancuso, ticket sales representative at the Utica Memorial Auditorium, who got me in free to hockey games in the 1970s and early 1980s.

INTRODUCTION

The Capital District of New York State has a storied hockey tradition. There have been six professional teams and four minor professional leagues that have called Albany, Schenectady, or Troy home. The Troy Uncle Sam's Trojans began the professional hockey tradition in New York's capital region in the 1952–1953 season as members of the Eastern Amateur Hockey League (EAHL). Players in the EAHL were classified as amateur players but were paid a salary. The Collar City team had several players with NHL experience on the squad, including U.S. Hockey Hall of Famer Bill Moe, Dick Bittner, Gordie Byers, Vic Howe, and Val Delory.

Professional hockey resurfaced in the area in 1981–1982 with the Schenectady Chiefs of the new Atlantic Coast Hockey League (ACHL). The Chiefs' general manager-coach was former Union College star Peter Crawford. Schenectady signed players who had college hockey experience in the Capital District area. Dean Willers and Mike Crawford of Union College, and Don Boyd, Jack Colucci, and Pierre Thibault of Rensselaer Polytechnic Institute (RPI) skated for the Chiefs. Troy had an ACHL entry in 1986–1987 when the homeless New York Slapshots moved upstate and were renamed the Troy Slapshots. The new Collar City ACHL team drew part of its roster from area-grown talent. Schenectady natives Curt Cole and Todd Flanigan, Watervliet native Steve Plaskon, and Troy native Jak Bestle skated for the Slapshots.

In 1990, a brand-new, major league–caliber, 15,000-seat, state-of-the-art facility named the Knickerbocker Arena was built in Albany. The facility enticed the oldest and one of the most successful International Hockey League (IHL) franchises, the Fort Wayne Komets, to relocate. In 1990–1991, the Albany Choppers became the first IHL team based in the Northeastern part of the United States since the mid-1950s. The Choppers, sponsored by Price Chopper Supermarkets, had several players with NHL experience on the team, such as Mike Blaisdell, Dale Henry, Alain Lemieux, and Dave Richter.

The Troy-based Capital District Islanders of the American Hockey League (AHL) was the first team in the capital region to be a top affiliate of a National Hockey League (NHL) franchise as the New York Islanders had their primary farm team in Troy from 1990 through 1993. During the 1990–1991 season, the Islanders (AHL) and the Choppers (IHL) gave the Capital District two professional teams in one season. During the club's three seasons, several top Islanders' (NHL) prospects were developed, including Dean Chynoweth, Dave Chyzowski, Rob DiMaio, Tom Fitzgerald, Travis Green, Jamie McLennan, and Dennis Vaske.

The Albany River Rats, the number-one farm team of the New Jersey Devils for 13 seasons (1993–2006), brought the Capital District its first professional hockey championship in the 1994–1995 season and developed New Jersey farmhands that later became members of Devils' Stanley Cup–winning teams. Sergei Brylin, John Madden, Jay Pandolfo, Petr Sykora, and Colin White are among the River Rat players who helped their parent team win NHL championships.

U.S. Hockey Hall of Famers John Cunniff and Robbie Ftorek coached the Albany team. Through 13 campaigns, the River Rats have also won two AHL regular-season titles (1994–1995 and 1995–1996) and three division titles (1994–1995, 1995–1996, and 1997–1998) and have qualified for the postseason seven times. The River Rats have truly established themselves as one of the top sporting attractions in the Capital District as well as in New York State.

The 2006–2007 season marks a new era in River Rats history as the locals have become the AHL affiliate of both the Carolina Hurricanes (NHL) and the Colorado Avalanche (NHL). The River Rats will continue to provide area fans with a high caliber of hockey and continue their quest of bringing another Calder Cup championship to the Capital District!

THE TROY UNCLE
SAM'S TROJANS

The first minor-league professional hockey team in New York's Capital District was the Troy Uncle Sam's Trojans. The Trojans were awarded an expansion team in the Eastern Amateur Hockey League (EAHL) in August 1952. The EAHL granting Troy a franchise climaxed two years of "missionary work" in which the EAHL's New York Rovers, based at Madison Square Garden, played a portion of their games in the Collar City. Rover manager Thomas Lockhart, who was also president of the EAHL and business manager of the New York Rangers (NHL), allowed his team to play a partial regular-season schedule (nine games in the 1950–1951 season and nine games in the 1951–1952 season) at the RPI Field House in order to promote hockey in the Troy area. Lockhart was also supporting the development and growth of peewee hockey in Troy.

The EAHL, which originated in December 1933, was composed of five teams during the 1952–1953 season. Players in the EAHL were paid a salary but were classified as amateur players. Troy's opponents included the Johnstown Jets, the expansion New Haven Nutmegs (a Cleveland Barons [AHL] farm team), Eddie Shore's Springfield Indians, and the Washington Lions (formerly the Boston Olympics).

The Uncle Sam's Trojans called the RPI Field House in Troy home and were piloted by player-coach Bill Moe. Wilf Field was president and general manager of the club. Field, who was originally slated as coach of the team, relinquished his coaching chores to Moe but did pilot some games during the season. Troy was an independent outfit and did not have an official NHL affiliation. Field did arrange for some NHL teams to assign surplus players to Troy. The New York Rangers, who disbanded their New York Rovers farm team prior to the start of the season, needed an outlet for some of their younger players and assigned NHL veteran Vic Howe, Cliff Hicks, and Art Stone. The Boston Bruins assigned top prospect Gordie Byers to the Collar City. Mrs. H. L. Garren, wife of the managing director of the RPI Field House, was responsible for suggesting the name Uncle Sam's Trojans—after the city's most-famous and best-known historical figure. The team's official colors were red, white, and blue.

Troy finished in last place with a 23-34-3 (.408) record and was just six points short in the standing of qualifying for the playoffs. Art Stone led the team in all three offensive categories—points (107), goals (52), and assists (55). Vic Howe ranked second on the team in each offensive category with 79 points, 27 goals, and 52 assists. The goaltending duties were split between Don "Nipper" O'Hearn, who had a 4.32 goals against average (GAA) in 19 games; Ron Diguer, who had a 5.50 GAA in 18 games; Dick Bittner, who had a 4.00 GAA in one game; and Cliff Hicks (statistics not available).

The Uncle Sam's Trojans were ready to take the ice for the 1953–1954 campaign, but the EAHL suspended operations due to a lack of teams. When the league was revived in the 1954–1955 season as the Eastern Hockey League (EHL), Troy did not ice a team. The EHL would exist until the 1972–1973 season and then split into two new leagues—the North American Hockey League (NAHL) and the Southern Hockey League (SHL). Troy would not have professional hockey again until 1986–1987.

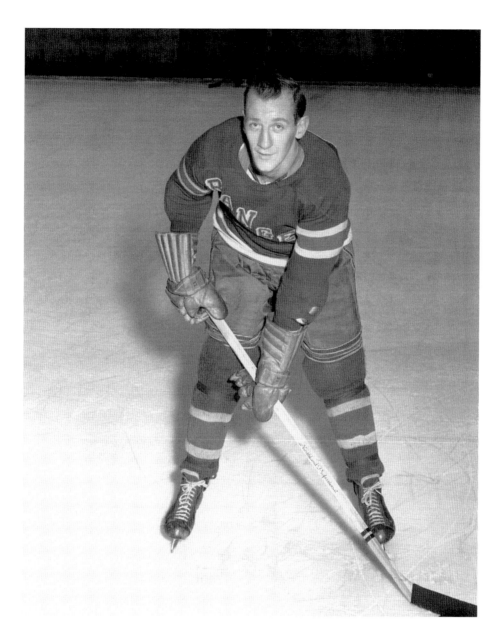

BILL MOE, PLAYER-COACH. The defenseman just missed leading the Uncle Sam's Trojans to an EAHL playoff spot with a 23-34-3 (.408) record. Moe played five seasons with the New York Rangers (NHL) from 1944–1949 and had the most NHL experience of any Troy player. He had 53 points, 42 assists, and 163 penalties in minutes (PIM) in 261 NHL games. For the Uncle Sam's Trojans, the mentor had 35 points, 23 assists, and 51 PIM in 57 games. He played two previous seasons in the EAHL with Atlantic City during the 1939–1940 season and Baltimore during the 1940–1941 season. Moe skated for six seasons in the AHL with Philadelphia in the 1941–1942 season and Hershey between 1942 and 1951. He was inducted into the U.S. Hockey Hall of Fame in 1974.

JOHN BROPHY, DEFENSE. Brophy is the all-time penalty minute king (3,825) of the Eastern League and also played more games (1,141) in league history than anyone else. The defenseman skated for the Uncle Sam's Trojans in four games and had eight penalty minutes. Brophy won two EHL playoff championships with Charlotte in 1956–1957 and Long Island in 1964–1965. As a coach, he won three East Coast Hockey League (ECHL) playoff championships with Hampton Roads in 1990–1991, 1991–1992, and 1997–1998. Brophy piloted Toronto (NHL) for three seasons from 1986–1989 and compiled a 64-111-18 (.378) record.

VAL DELORY, LEFT WING. The left-winger was third on the team in points (61) and goals (24). He also had 37 assists and two PIM in 40 games with the Uncle Sam's Trojans. Delory previously played in the EAHL with New York from 1947 to 1950 and Boston in 1951–1952. In 1949–1950, he won the John Carlin Trophy as the EAHL's leading scorer and was named an EAHL first team all-star. Delory had a stint in the NHL with the Rangers in 1948–1949.

GORDIE BYERS, DEFENSE. Byers led Troy in penalty minutes with 103. He also had 16 points and 13 assists in 56 games. He previously spent two seasons in the EAHL with Boston in 1949–1950 and 1951–1952. The defenseman also played in the United States Hockey League (USHL) in 1950–1951 and had a stint in the NHL with Boston in 1949–1950.

GORD PEARSON, DEFENSE. Pearson had six points, three goals, and four PIM in 14 games with Troy. The defenseman spent two seasons in the AHL with St. Louis from 1950 to 1952 and skated in the USHL with Milwaukee in 1950–1951.

DON "NIPPER" O'HEARN, GOALIE. "Nipper" was between the pipes in 19 games with the Uncle Sam's Trojans and compiled a 4.32 GAA. He played eight seasons in the Eastern League between 1947 and 1963 (including Troy) and compiled a 4.04 GAA in 87 games. O'Hearn played for two Atlantic City Boardwalk Trophy championship teams: Clinton (EHL) in 1958–1959 and Greensboro (EHL) in 1962–1963. The journeyman goaltender also played in the AHL, IHL, USHL, and Quebec Hockey League (QHL).

VIC HOWE, RIGHT WING. The right-winger ranked second on the Uncle Sam's Trojans in points (79), goals (27), and assists (52). Howe played in three seasons with the New York Rangers between 1950 and 1955. He had 7 points, 4 assists, and 10 PIM in 33 NHL games. Howe played in the IHL in 1948–1949, the AHL in 1951–1952, the Western Hockey League (WHL) from 1952 to 1956, and the QHL in 1954–1955. Vic is the brother of hockey legend Gordie Howe.

DUNC DANIELS. Daniels had 29 points, 20 assists, and 12 PIM in 44 games with the Uncle Sam's Trojans. He competed in two Memorial Cup playoffs while playing with the Winnipeg Monarchs in 1944–1945 and 1945–1946.

HERB SCHILLER, LEFT WING. The left-winger had 12 points, 8 goals, and four PIM in 15 games. Schiller also played two other seasons in the Eastern League with Baltimore from 1954 to 1956 and skated for one year in the IHL with Grand Rapids in 1953–1954.

BILL HAGEN, LEFT WING. Hagen had seven points, four assists, and 12 PIM in 23 games with Troy. He played two seasons in the Pacific Coast Hockey League (PCHL)/ Western Hockey League (WHL) with Vancouver in 1951–1952 and 1952–1953 and spent one campaign in the AHL with Buffalo in 1951–1952.

LORNE HENNESSEY, FORWARD. The forward had 35 points, 19 assists, and 37 PIM in 51 games with the Troy Uncle Sam's Trojans.

TROY UNCLE SAM'S TROJANS LOGO. The nickname Uncle Sam's Trojans has a deep association with American history. Troy has been associated with Uncle Sam since the War of 1812. As the story goes, during the war, Sam Wilson was a meat packer (meat used to be packed in barrels) living and working in Troy. Each barrel of meat rations was stamped "US" before it was shipped to the soldiers. The soldiers of that time equated their U.S.-supplied rations with "Uncle Sam" Wilson. The story grew to mythological proportions, resulting in a somewhat fictional image of Sam Wilson emerging as the white bearded, red-white-and-blue-clad symbol of America. The best-known Uncle Sam image originated over 50 years ago as part of a wartime recruitment poster, encouraging qualified citizens to join the armed forces, "I want you." The Troy hockey club incorporated the image of Uncle Sam on the recruitment poster into its team logo.

THE ATLANTIC COAST HOCKEY LEAGUE TEAMS

The Schenectady Chiefs

The Intercontinental Major Hockey League (IMHL) was being organized with the help of mutual fund broker Lou Bodnar and Waterville businessman Bob Critelli. The IMHL released its schedule for a five-team loop in July 1981, consisting of Schenectady; Clinton; Fitchburg, Massachusetts; Pittsfield, Massachusetts; and Worcester, Massachusetts. By early September, however, the Pittsfield franchise was not ready to operate, leaving only four teams in the league and forcing the IMHL to suspend operations. The remaining teams hoped to join the newly organized Atlantic Coast Hockey League (ACHL).

In September 1981, the ACHL admitted Schenectady and Fitchburg for a seven-team circuit. The Schenectady Chiefs were owned by former IMHL organizer Bob Critelli, and former Union College star Peter Crawford served as the club's general manager-coach. Schenectady's roster was heavily stocked with players from the American college ranks, including several from Capital District schools.

The Chiefs have the distinction of playing in the first game in ACHL history on October 23, 1981, against the Fitchburg Trappers (a 5-3 loss) at Fitchburg. Schenectady won its home opener on October 24, 1981, against the Cape Cod Buccaneers, 5-2, in front of 650 fans at the Schenectady Civic Center (hockey capacity of 2,500). The locals put together three consecutive wins amid their next five games to manage a 4-4 record. Just when it looked like the team was coming together on the ice, the Chiefs began to experience financial difficulties. The team's financial problems were due to low attendance and under-financing by ownership. Owner Bob Critelli was unable to meet team expenses, and the Chiefs franchise was suspended when the club was unable to produce the league-required $15,000 performance bond. After handing down the suspension, the ACHL decided to subsidize the Chiefs for one week, mainly to give Bob Critelli time to sell the team. Following an 8-2 loss versus the Salem Raiders on November 11, 1981, in front of 350 fans at Schenectady, league officials suspended the team once again. After attempts were made to move the franchise to Richmond, Virginia, and to sell the team to local investors were unsuccessful, the league terminated the Schenectady franchise in a league meeting on November 15, 1981.

The Chiefs finished with a 4-5 record and averaged fewer than 400 fans per game for six home dates. Dean Willers led the team in points (17) and goals (9), while Mike Crawford had the most assists (10). Garry Scott (4.33 GAA in six games) and Wayne Burrows (5.87 GAA in four games) split the goaltending duties.

The Troy Slapshots

The city of Troy had professional hockey for the first time in 33 years when the ACHL's New York Slapshots relocated to the Collar City for the 1986–1987 season. New York played the entire 1985–1986 ACHL season on the road as a result of its proposed home rink, the Phil Esposito Arena on Staten Island, never getting built. The club moved upstate to RPI's 5,300-seat Houston Field House for the 1986–1987 season. Troy was also the site of the ACHL's rookie camp in October 1986. The Slapshots' general manager–coach was Joe Selenski, and the team was owned by Rudy Slucker. Scott Talarowski was the team's assistant coach. The Slapshots did not have an affiliation with an NHL team but had a contractual agreement with the Saginaw Generals of the International Hockey League (IHL), who were a team affiliated with the Montreal Canadiens (NHL).

Troy won its home opener on October 25, 1986, against the Mohawk Valley Comets, 8-5, in front of 1,312 fans. After losing four straight games, rumors began circulating that the Slapshots, plagued by poor home crowds, would soon fold. On November 15, 1986, the Slapshots would play their last game—a 3-2 shootout win at the Erie Golden Blades—to finish with a 2-4 record. A league meeting was held in Utica on November 17 to resolve the team's financial situation. After a long discussion, the Slapshot franchise was revoked, bringing the loop down to four teams. Instead of holding a dispersal draft, the league decided to give the rights of the Troy players to the struggling Mohawk Valley Comets, who had a 1-8 start. Joe Selenski became the general manager–coach of the Comets and had 10 days to merge the Troy and Mohawk Valley rosters down to the 15-man limit. Once the rosters were consolidated into one squad, the majority of the players were former Slapshots. In the Slapshots six-game history, Joe DeMitchell led the team in points (seven) and assists (four), while Steve Plaskon and Todd Flanigan tied for most goals with four. Stuart Gould spent the most games between the pipes with four.

The amalgamated Comet/Slapshot team was very successful and was only one game short of winning the ACHL championship—losing four games to three in the finals against the Virginia Lancers.

PIERRE THIBAULT, DEFENSE. Thibault had one point on one goal and registered four PIM in four games with the Chiefs. Prior to coming to Schenectady, he played four years with RPI from 1977 to 1981. The defenseman skated in the IHL with Flint from 1982 to 1985 and won a Turner Cup championship with the club in 1983–1984.

JACK COLUCCI, DEFENSE. One of only five players to appear in all nine of the Chiefs games, Colucci garnered seven points, five assists, and 12 PIM with Schenectady. He also played in the ACHL with Baltimore in 1981–1982 and skated in the IHL with Saginaw in 1982–1983. The defenseman played college hockey with RPI from 1977 to 1981, totaling 58 points, 44 assists, and 153 PIM.

JIM COWELL, FORWARD. Cowell was a member of four playoff championship teams. He won a Lockhart Cup with Syracuse (NAHL) in 1976–1977, two Mitchell Cups with Erie (EHL) in 1979–1980 and 1980–1981, and one Payne Trophy with Erie (ACHL) in 1982–1983. The forward played in one game with Troy. In ACHL history, Cowell ranks third in games played (272), sixth in assists (208), tied for sixth in points (343), and ninth in goals (135).

THE TROY SLAPSHOTS LOGO. After an ACHL board of governors meeting held to save the Troy Slapshot franchise failed and the franchise was revoked, ACHL commissioner Ray Miron stated "that a team with such a nickname could never last" and "if the history of the Slapshots is ever written, it would make a good sequel to the movie of the same name." The movie that Ray Miron was referring to was the 1977 film *Slap Shot* starring Paul Newman. The story was based on the Johnstown (Pennsylvania) Jets North American Hockey League (NAHL) championship team of 1974–1975 and their unlikely rise to the NAHL title. The screenplay was written by Nancy Dowd, sister of Jets winger Ned Dowd. The film was shot almost entirely in Johnstown, Pennsylvania. The Hanson brothers, who stole the show, were based on the Carlson brothers—Jack, Jeff, and Steve—all actual members of the Johnstown Jets. All three were slated to act in the movie, but Jet teammate Dave Hanson took over for Jack, who was up in the World Hockey Association (WHA).

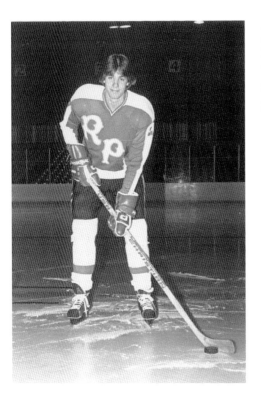

JAK BESTLE, FORWARD. Bestle had three points, two assists, and four PIM in five games with the Slapshots. He skated with RPI for four seasons from 1979 to 1983, garnering 13 points, 6 goals, and 32 PIM in 46 games.

DON BOYD, RIGHT WING. He had six points, two goals, and 12 PIM in seven games with Schenectady. Boyd also played in the ACHL with Baltimore in 1981–1982 and spent time in the IHL with Port Huron from 1979 to 1981 and the Central Hockey League (CHL) with Salt Lake City in 1979–1980. The right-winger was selected by St. Louis in round 12 (No. 191 overall) of the 1978 NHL entry draft.

3

A New Arena
and a New Team

In the fall of 1990, David Welker, owner of the Fort Wayne Komets of the International Hockey League (IHL), opted to move his franchise to Albany and its brand-new, major-league-caliber, 15,000-seat facility—the Knickerbocker Arena. The Fort Wayne franchise had been a member of the IHL since the 1952–1953 season and was the oldest and one of the most successful franchises in IHL history. Neil Golub, president of Price Chopper—a regional supermarket chain based in Albany—became a major investor of the franchise, and the team was renamed the Albany Choppers. The club also donned the corporate red, white, and blue colors of the grocery chain. Albany became the first IHL team based in the Northeastern part of the United States since the Johnstown (Pennsylvania) Jets took the ice from 1953 to 1955.

The Choppers began play in the 1990–1991 season and were coached by David Allison. The team's general manager was Jim Salfi, and former NHL defenseman Dave Richter was signed as player/assistant coach. Albany did not have a primary affiliation with an NHL team, but the Vancouver Canucks (NHL) signed an agreement to make the club their secondary affiliate. The Choppers also had players that were property of other NHL teams on their roster.

The club had less than 1,000 season-ticket holders and had a hard time attracting fans early on because of competition from two nearby American Hockey League (AHL) franchises. The AHL Capital District Islanders were starting their inaugural season in nearby Troy in 1990–1991, and the established three-time Calder Cup–winning Adirondack Red Wings (AHL members since 1979–1980) were less than 50 miles north in Glens Falls.

The three teams all suffered at the gate through subsequent price wars, but the Choppers suffered the worst at the box office because they were mired in last place and did not have any natural geographic rivalries like the AHL clubs in the area. Albany was also forced to pay travel expenses to visiting teams at home games and had a costly travel budget. The team hemorrhaged funds, and eventually the debt began to snowball. In mid-February, the payroll and traveling expenses for an upcoming road trip could not be met. After a deal with local buyers to purchase and save the team fell through, the Choppers folded on February 15, 1991, from a lack of funds. Albany owner David Welker said that he could no longer finance the team and was forced to forfeit the $750,000 it originally cost him for the franchise. The Choppers averaged just over 2,000 fans per game for their 30 home dates and needed an average of 4,000 patrons per game to break even. Plagued by small crowds, competition from two other pro hockey teams in the area, and a slow start on the ice, the Choppers never really got airborne.

Albany completed only 55 of the IHL's 82-game schedule, earning a 22-33 (wins-losses) record (.427 which includes three points from overtime losses). Alain Lemieux had the most

points (41) and the most assists (36) on the team, and Yves Heroux scored the most goals (22). Goaltender John Blue led the team in wins (11-6-0 record) and GAA (3.96), while Bruce Racine appeared in the most games between the pipes (29) with the club.

A NEW ARENA AND A NEW TEAM

DAVE RICHTER, DEFENSE. The Choppers player/assistant coach amassed 1,030 PIM, 49 points, and 40 assists in 365 games during his nine-year NHL career from 1981 to 1990. He had 128 PIM and one point in 41 games with the Choppers. The defenseman played one other season in the IHL in 1989–1990 and spent time in the AHL and the CHL.

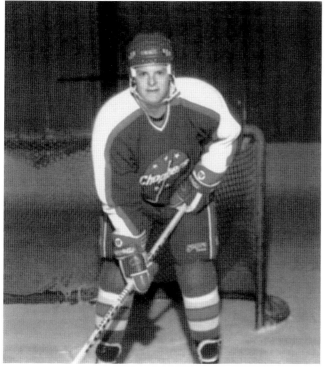

YVES HEROUX, RIGHT WING. Heroux led the Choppers in goals with 22 and was second on the team in points with 40. He also had 18 assists and 46 PIM in 45 games with Albany. The right-winger spent a total of nine years in the IHL between 1985 and 1995. Heroux had a stint in the NHL with Quebec in 1986–1987. He was a member of the Canadian National Team in 1989–1990.

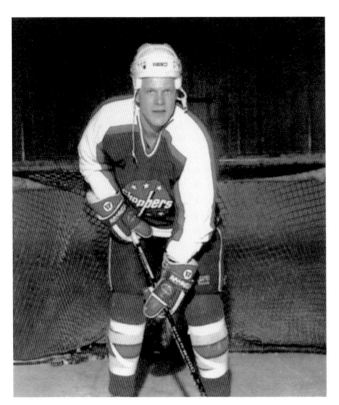

NICK BEAULIEU, LEFT WING.
The left-winger had 38 points, 17 goals, and 69 PIM in 49 games with Albany. Beaulieu also skated in the IHL with Phoenix from 1989 to 1991 and Kalamazoo in 1991–1992. He spent time in the AHL in 1988–1989, the ECHL in 1991–1992, and the CHL in 1992–1993.

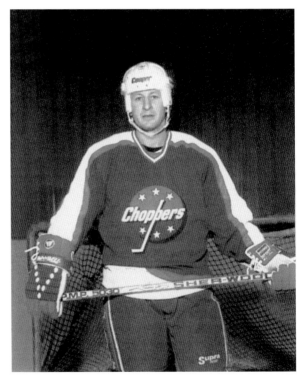

TORRIE ROBERTSON, LEFT WING.
The 10-year NHL veteran (1980–1990) amassed 1,751 PIM, 148 points, and 99 assists in 442 games. He skated in one game with Albany. The left-winger played four seasons in the AHL between 1981 and 1991.

A NEW ARENA AND A NEW TEAM

IVAN MATULIK, RIGHT WING. Matulik played only three games with Albany and had two PIM. He also skated in the IHL with Phoenix in 1989–1990 and spent time in the AHL from 1987 to 1993.

GORDON PADDOCK, CENTER. Paddock had 19 points, 16 assists, and 49 PIM in 53 games with the Choppers. Prior to arriving in Albany, he played two seasons in the IHL from 1984 to 1986 and skated for Turner Cup–winning Muskegon in 1985–1986. The center also played seven years in the AHL from 1984 to 1991.

DARRYL NOREN, CENTER. Noren only spent seven games with the Choppers and had two PIM. He spent most of his professional career in the ECHL from 1990 to 2000 and was a member of Riley Cup–winning Charlotte in 1995–1996. The center resurfaced in the IHL with San Antonio in 1996–1997. Noren also played in the AHL from 1991 to 1993, the Colonial Hockey League (CoHL) in 1993–1994, and the CHL in 2000–2001.

CURTIS HUNT, DEFENSE. Hunt accumulated 122 PIM, 14 points, and 12 assists in 45 games with Albany. He also skated in the IHL with Flint in 1987–1988, Milwaukee from 1988 to 1991, Houston from 1994 to 1996, and Michigan in 1995–1996. The defenseman spent time in the AHL between 1987 and 1994.

ROB MACINNIS, DEFENSE. The defenseman had 18 points, 9 goals, and 74 PIM in 38 games with the Choppers. He split the 1990–1991 IHL campaign between Albany and San Diego. MacInnis skated in the AHL between 1985 and 1993, the ECHL between 1993 and 1997, and the CoHL/United Hockey League (UHL) from 1995 to 1998.

VERN SMITH, DEFENSE. Smith had 20 points, 15 assists, and 48 PIM in 46 games with Albany. The New York Islanders' second-round pick (No. 42 overall) of the 1982 NHL entry draft had a stint with the Long Island–based team in 1984–1985. The defenseman played two other seasons in the IHL (1989–1990 and 1991–1992). He spent most of his career in the AHL and also spent time in the CHL and ECHL.

RICK KNICKLE, GOALIE. Knickle was between the pipes with four playoff championship teams—Mitchell Cup–winning Erie (EHL) in 1980–1981, Calder Cup–winning Rochester (AHL) in 1982–1983, Turner Cup–winning Flint (IHL) in 1983–1984, and Calder Cup–winning Springfield (AHL) in 1990–1991. He spent 16 seasons in the IHL between 1979 and 1997 and played in net for 11 different IHL cities. He won the IHL's James Norris Memorial Trophy as outstanding goaltender in 1988–1989 and shared the award in 1992–1993. In his two seasons in the NHL with Los Angeles from 1992 to 1994, the goalie had a 3.74 GAA and a 7-6-0 record in 14 games. Knickle had a 4.59 GAA and a 4-6-2 record in 14 games with Albany.

A NEW ARENA AND A NEW TEAM

STUART BURNIE, RIGHT WING. He played with the Canadian National Team for two seasons in 1985–1986 and 1990–1991. Burnie produced 35 points, 16 goals, and 73 PIM in 53 games with the Choppers. The right-winger also played in the IHL with Fort Wayne in 1990–1991 and spent time in the AHL from 1986 to 1989.

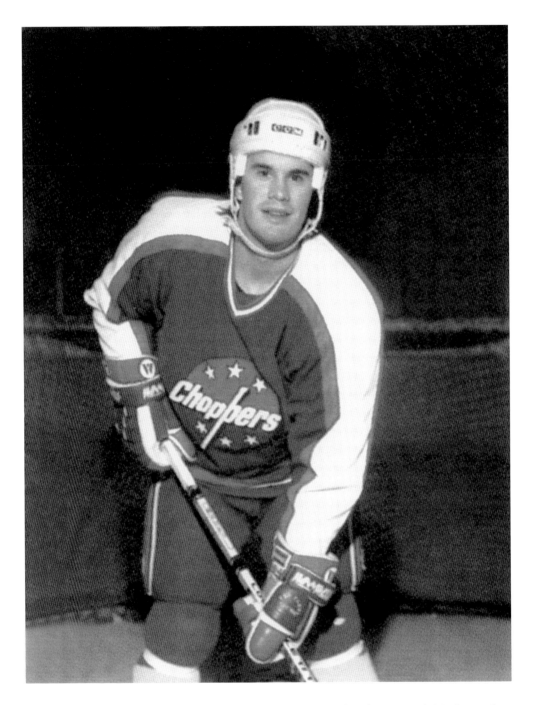

JEFF WAVER, DEFENSE. The defenseman had 15 points, 9 assists, and 18 PIM in 32 games with the Choppers. Prior to coming to Albany, Waver played in the IHL with Muskegon from 1988 to 1990 and the ECHL with Virginia in 1989–1990.

DAN WOODLEY, CENTER. Woodley was the Vancouver Canucks' number-one pick (No. 7 overall) of the 1986 NHL entry draft. The center skated in five games with Vancouver (NHL) during the 1987–1988 season. Woodley had 25 points, 17 assists, and 36 PIM in 31 games with Albany. He played in two other IHL seasons from 1987 to 1989 and was the winner of the IHL's Ken McKenzie Trophy in 1987–1988 as American-born rookie of the year.

BRUCE RACINE, GOALIE. Racine appeared in the most games between the pipes for the Choppers with 29. The goalie earned a 3.98 GAA and a 7-18-1 record with Albany. He played a total of 10 seasons in the IHL between 1988 and 2000 and helped Muskegon capture the Turner Cup in 1988–1989. Racine was called up to the NHL in 1995–1996 and had a 3.13 GAA and a 0-3-0 record in 11 games.

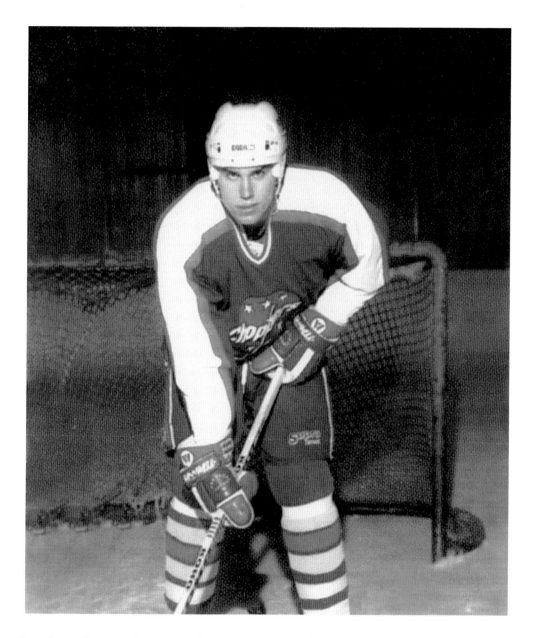

PAUL LAUS, DEFENSE. Laus amassed 1,702 PIM, 72 points, and 58 assists in 530 NHL games during his nine seasons in the league from 1993 to 2002. The defenseman played seven games with Albany and had seven PIM. He also skated in the IHL with Muskegon from 1990 to 1992 and Cleveland in 1992–1993. Laus spent one season in the ECHL in 1990–1991.

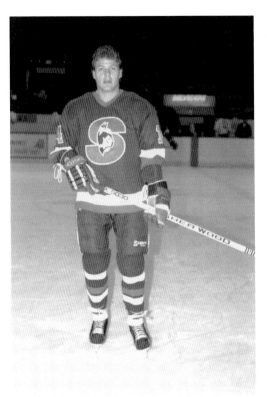

JIM MCGEOUGH, CENTER. The center split the 1990–1991 IHL season between Albany, Kalamazoo, and San Diego. He had 12 points, 9 goals, and four PIM in 12 games with the Choppers. McGeough is a veteran of four NHL seasons between 1981 and 1987. He had 17 points, 10 assists, and 32 PIM in 57 NHL games. Besides the IHL, the journeyman player made stops in six other minor professional leagues.

CRAIG CHARRON, CENTER. Charron skated in five games with the Choppers and had two points on two assists. He also played in the IHL with Cincinnati in 1992–1993 and with Fort Wayne and Kalamazoo in 1994–1995. The center spent most of his professional career in the AHL between 1990 and 2002 and won a Calder Cup with Rochester (AHL) in 1995–1996. He was awarded the AHL's Fred T. Hunt Memorial Award in 1997–1998 for sportsmanship, determination, and dedication to hockey.

A NEW ARENA AND A NEW TEAM

JOHN BLUE, GOALIE. Blue led the Choppers in GAA (3.96) and wins (11-6-0) in the team's abbreviated season. He played a total of five seasons in the IHL between 1987 and 1996 with five different teams. The goalie played three seasons in the NHL between 1992 and 1996, and he had a 3.00 GAA and a 16-18-7 record in 46 games. Blue was a member of the U.S. National Team in 1987–1988.

KRAIG NIENHUIS, LEFT WING. Nienhuis had four points and three goals in three games with the Choppers. In his three campaigns in the NHL from 1985 to 1988, Nienhuis had 36 points, 20 goals, and 39 PIM in 87 games. The left-winger skated for the Canadian National Team in 1988–1989. He spent time in the AHL from 1986 to 1988 and the UHL from 1998 to 2001.

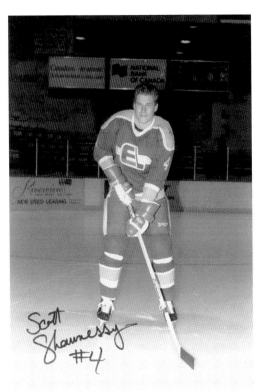

SCOTT SHAUNESSY, DEFENSE. Shaunessy had 126 PIM, 12 points, and 9 assists in 34 games with the Choppers. He spent three other seasons in the IHL between 1989 and 1993. In his two years in the NHL (1986–1987 and 1988–1989), he had 23 PIM in seven games. The defenseman also skated in the AHL and Western Professional Hockey League (WPHL).

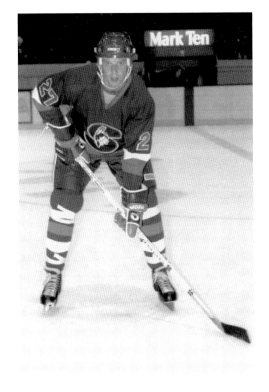

BOB BODAK, LEFT WING. In his five games with Albany, Bodak had 13 PIM, two points, and one goal. The left-winger spent three other seasons in the IHL with Salt Lake City from 1987 to 1989 and San Diego in 1990–1991, and he won a Turner Cup with Salt Lake City in 1987–1988. Bodak had two stints in the NHL with Calgary in 1987–1988 and Hartford in 1989–1990 and had 29 PIM in four NHL games.

A NEW ARENA AND A NEW TEAM

PAUL JERRARD, DEFENSE. Jerrard compiled 30 PIM and three assists in seven games with the Choppers. He played a total of eight seasons in the IHL between 1987 and 1996. The defenseman spent three seasons in the AHL from 1994 to 1997 and won a Calder Cup with Hershey in 1996–1997. He skated in five games with Minnesota (NHL) in 1988–1989 and was an assistant coach with Colorado (NHL) during the 2002–2003 season.

ALAIN LEMIEUX, CENTER. The center led the Choppers in points (41) and assists (36). He is a veteran of six NHL seasons from 1981 to 1987 and compiled 72 points, 44 assists, and 38 PIM in 119 games. Lemieux played two other seasons in the IHL between 1984 and 1989. He skated for Calder Cup–winning Hershey (AHL) in 1987–1988. Alain's brother is hockey legend Mario Lemieux.

Soren True, Left Wing. One of only two Chopper players to appear in each of the team's 55 games, True garnered 31 points, 15 goals, and 40 PIM with the Choppers. He also skated in the IHL with Flint in 1989–1990, San Diego from 1990 to 1992, and Phoenix in 1991–1992.

Emanuel Viveiros, Defense. The defenseman had 10 points, 7 assists, and six PIM in 14 games with the Choppers. He played two other seasons in the IHL from 1987 to 1989. In his three seasons in the NHL from 1985 to 1988, Viveiros had 12 points, 11 assists, and six PIM in 29 games. He also spent two seasons in the AHL (1986–1987 and 1990–1991) and won a Calder Cup with Springfield in 1990–1991.

A NEW ARENA AND A NEW TEAM

RYAN STEWART, CENTER. In Stewart's one game with Albany, he had 10 PIM. The Winnipeg Jets' number-one pick (No. 18 overall) of the 1985 NHL entry draft skated in three games with the Jets and scored one goal. The center spent two years in the AHL from 1987 to 1989.

MIKE BLAISDELL, RIGHT WING. Blaisdell had two points and two goals in six games with the Choppers. He played nine seasons in the NHL from 1980 to 1989 with Detroit, Pittsburg, the Rangers, and Toronto and had 154 points, 70 goals, and 166 PIM in 343 games. The right-winger played for Adams Cup–winning Tulsa (CHL) in 1983–1984 and Calder Cup–winning Adirondack (AHL) in 1980–1981. He also played with the Canadian National Team in 1989–1990.

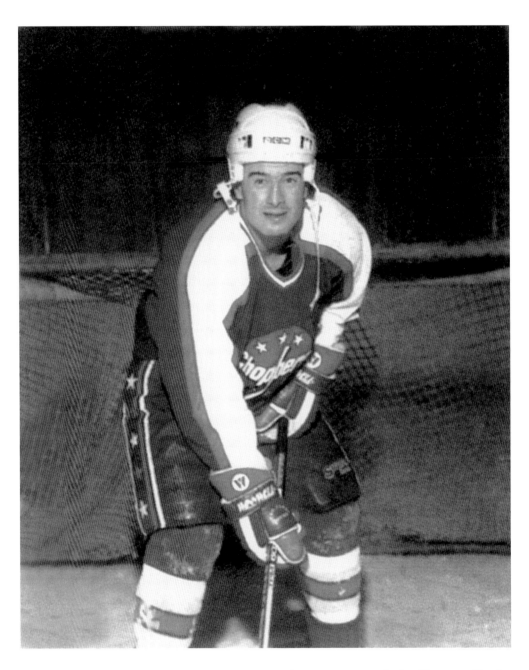

BYRON LOMOW, CENTER. Lomow spent most of his professional career in the IHL, playing in the league from 1985 to 1991. The center accumulated 177 PIM, 21 points, and 12 goals in 40 games with the Choppers. He also played in the AHL in 1987–1988, the ECHL in 1991–1992, and the CoHL in 1992–1993.

A NEW ARENA AND A NEW TEAM

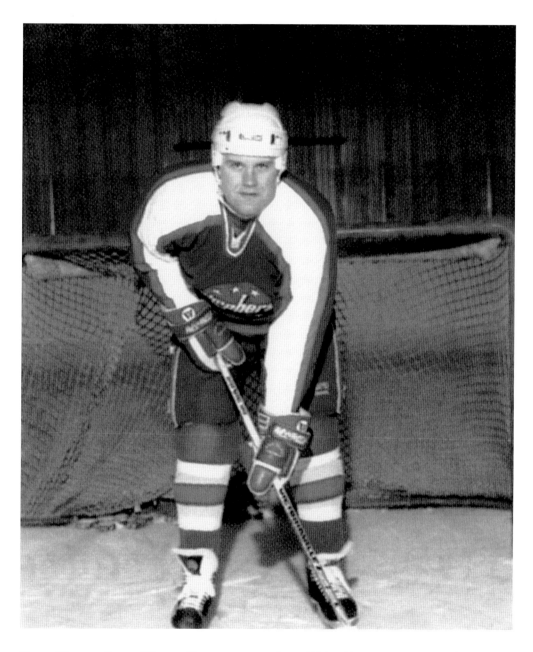

DALE HENRY, LEFT WING. Henry was a member of five playoff championship teams. He won two Calder Cups with Springfield (AHL) in 1989–1990 and 1990–1991 and three consecutive President's Cups with Shreveport (WPHL) and Bossier/Shreveport (WPHL) from 1998–1999 to 2000–2001. The six-year NHL veteran (1984–1990) accumulated 263 PIM, 39 points, and 26 assists in 132 games. Henry had 38 points, 22 assists, and 87 PIM in 55 games with Albany.

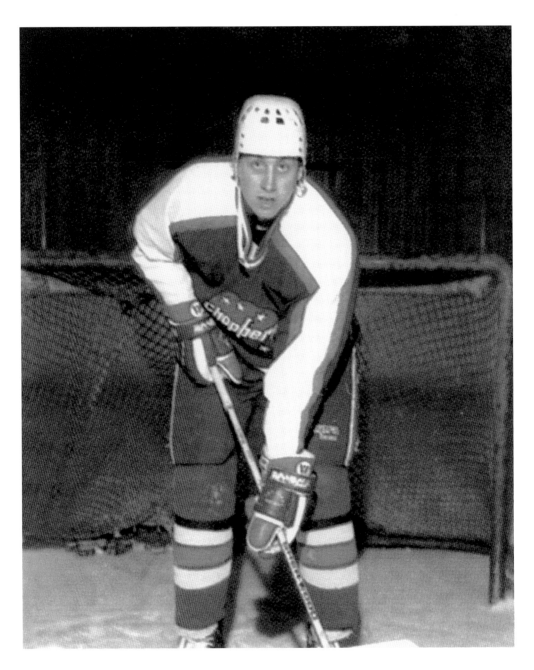

JOE STEFAN, CENTER. Stefan produced 23 points, 14 assists, and 49 PIM in 38 games with the Choppers. The center spent his entire North American professional career in the IHL.

Besides Albany, he also skated in the IHL with Peoria in 1987–1988, Fort Wayne from 1988 to 1990, and San Diego in 1990–1991.

A NEW ARENA AND A NEW TEAM

4

THE ISLANDERS PUT THEIR TOP FARM TEAM IN TROY

The Capital District Islanders began play in the American Hockey League (AHL) during the 1990–1991 season. The team played at RPI's 5,203-seat Houston Field House in Troy, the brief home of the ACHL's Slapshots four years earlier. The Capital District Islanders, affiliated with the NHL's New York Islanders, quickly came into existence after the IHL moved into nearby Albany with the Albany Choppers. The AHL had opposed expansion into Albany due to its close proximity to Glens Falls (it was within the league's 50-mile territorial limit), but the league quickly worked out a deal after the IHL invasion. Mike Cantanucci, owner of the Capital District Islanders, who bought a dormant AHL franchise for $500,000, would have to pay the Adirondack Red Wings $1 million up front, plus $50,000 a year for 10 years along with a percentage of the revenues from parking and ticket sales. Since the Choppers were members of a different league, they did not have to pay any territorial fees to the Red Wings.

The New York Islanders assigned Butch Goring to coach Capital District, and Goring would pilot the franchise during its three-year history. Kevin Earl was named general manager during the first season, while David Hanson was the team's general manager during its second and third campaigns. The Islanders (AHL) were inheriting players who won the Calder Cup with the New York Islanders' (NHL) primary affiliate in Springfield (AHL) during the previous season. Capital District began its inaugural season with close to 1,500 season-ticket holders, and given more time, it appeared that they would have reached their goal of 2,000 season tickets.

In their first season in 1990–1991, the Capital District Islanders finished in seventh place out of eight teams in their division with a 28-43-9 record and did not make the postseason. The team drew 101,592 fans for 40 home dates (2,540 per game). Greg Parks led the team in all three offensive categories—75 points, 32 goals, and 43 assists. George Maneluk spent the most time between the pipes (29 games) and compiled a 4.06 GAA and a 10-14-1 record for Capital District. Kevin Cheveldayoff established the all-time team single-season penalty minute mark with 203 PIM that season.

The Islanders (AHL) improved to a 32-37-11 record in 1991–1992, finished fourth out of five teams in their division in the realigned AHL, and made the playoffs for the first time. Greg Parks again led the team in all three offense departments, but this time, he placed seventh in AHL scoring with 93 points. Danny Lorenz set all-time Islander (AHL) single-season marks for games in goal (53), wins (22), and shutouts (2). Attendance dropped to 82,507 for 40 home games

(just over 2,000 per game). In the postseason, the locals lost in a seven-game opening-round thriller to the Springfield Indians.

Capital District reached the .500 mark in its 1992–1993 campaign with a 34-34-12 record, qualifying for the playoffs once again. AHL second team all-star center Iain Fraser placed second in AHL scoring and set all-time Islander (AHL) single-season records in points (110), goals (41), and assists (69). Jamie McLennan, who placed third in AHL goaltending, set the team single-season record for GAA with 3.23 in 38 games. Home crowds averaged 2,073 fans per game for a total of 82,950 patrons in 40 home games. In the "second season," Capital District was swept in four straight games in the opening round against rival Adirondack.

The New York Islanders withdrew their affiliation after the 1992–1993 season and moved their players to the Salt Lake City Golden Eagles of the IHL for the 1993–1994 campaign. Albert Lawrence, Capital District Islanders' owner, established an affiliation with the New Jersey Devils (NHL) for the Troy-based AHL franchise. Lawrence relocated the franchise to the Knickerbocker Arena in Albany and renamed the team the Albany River Rats.

The Capital District Islanders lasted only three seasons and compiled an overall record of 94-114-32 (.458). Greg Parks is the all-time franchise leader in points (168), Brent Grieve is the team's all-time leader in goals (82), and Richard Kromm is the club's all-time leader in assists (109) and games played (231). Dean Chynoweth is the Islanders' (AHL) all-time penalty minute king with 537 PIM. Capital District drew 267,049 fans (2,225 per game) at the RPI's Houston Field House in its three campaigns.

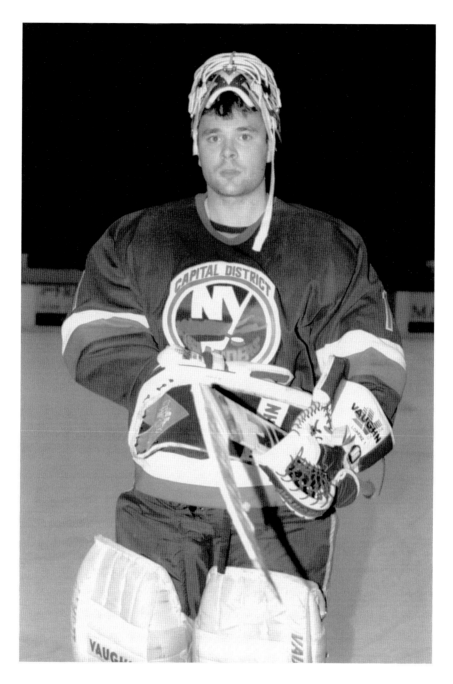

DANNY LORENZ, GOALIE. Lorenz ranks first all-time in games between the pipes (114), wins (43), and shutouts (3) in Capital District history. The goalie compiled a 3.72 GAA and a 43-48-14 record during his three seasons with the Islanders (AHL). He also holds Capital District single-season records for games in net (53), wins (22), and shutouts (2) set in 1991–1992. A veteran of three NHL seasons from 1990 to 1993, Lorenz had a 4.20 GAA and a 1-5-0 record in eight games.

HOCKEY IN THE CAPITAL DISTRICT

JAMIE McLENNAN, GOALIE. McLennan is Capital District's all-time and single-season GAA leader. He earned a 3.40 GAA during his two seasons with the Islanders (AHL) from 1991 to 1993 and set the team record for the lowest GAA in one campaign in 1992–1993 with a 3.23 mark. The goaltender compiled a 21-24-8 record in 56 games with Capital District. A 10-year NHL veteran between 1993 and 2006, McLennan put together a 2.64 GAA and a 77-104-35 record in 245 games. He won the NHL's Bill Masterton Memorial Trophy in 1997–1998 for perseverance, sportsmanship, and dedication to hockey.

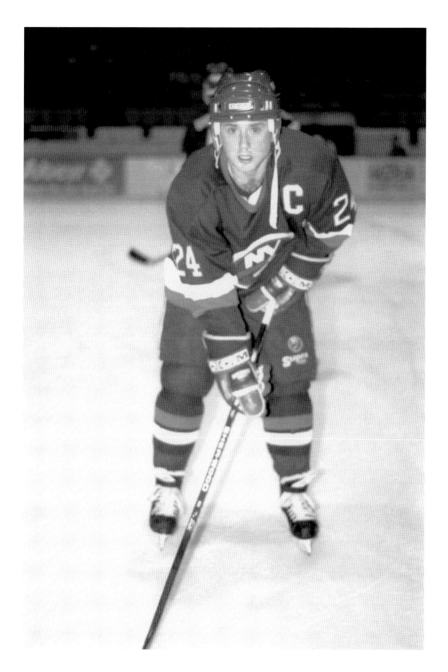

GREG PARKS, RIGHT WING. Parks is the all-time leader in points (168) in Capital District history. The right-winger also ranks second in goals (68) and assists (100) on the Islanders' (AHL) all-time list. He led Capital District in all three offensive categories during both of his seasons with the club in 1990–1991 and 1991–1992. Parks had 151 PIM in 118 games with the Isles (AHL). He appeared in three NHL campaigns from 1990 to 1993 and had three points, two assists, and six PIM in 23 games. The Capital District scoring king was a member of the Canadian National Team for four seasons between 1992 and 2000.

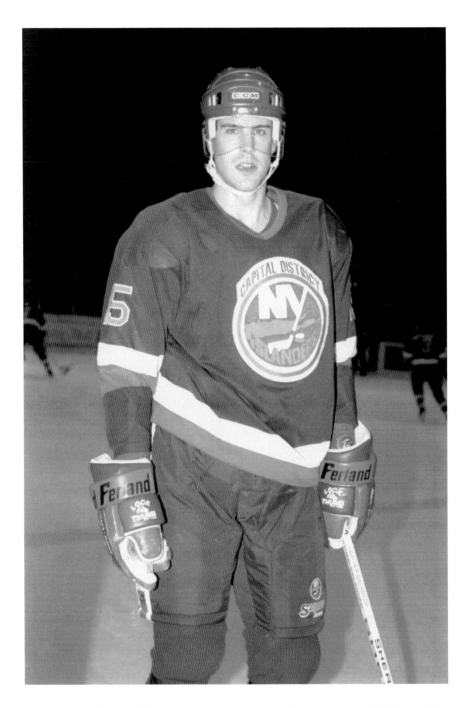

BRAD DALGARNO, RIGHT WING. Dalgarno was the New York Islanders' number-one (No. 6 overall) pick of the 1985 NHL entry draft. In his 10 seasons in the NHL between 1985 and 1996, the right-winger tallied 120 points, 71 assists, and 332 PIM in 321 games. Dalgarno played with Capital District from 1990 to 1993 and garnered 49 points, 26 assists, and 76 PIM in 60 games.

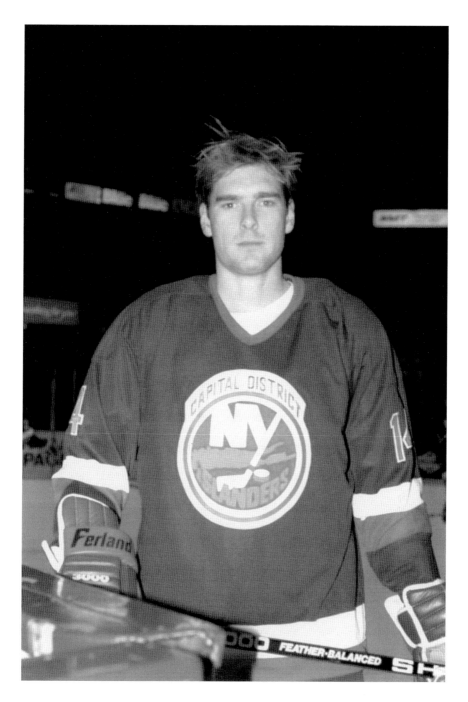

TOM KURVERS, DEFENSE. He was the winner of the 1983–1984 Hobey Baker Award (National Collegiate Athletic Association [NCAA] Division I MVP). Kurvers tallied 421 points, 328 assists, and 350 PIM in 659 games during his 11-year NHL career from 1984 to 1995. He played seven games with Capital District in 1992–1993 and had seven points, four assists, and eight PIM.

RICH PILON, DEFENSE. Pilon racked up 1,745 PIM, 77 points, and 69 assists in 631 games during his 14-year NHL career from 1988 to 2002. The defenseman appeared in six games with Capital District in 1992–1993 and registered one point and eight PIM. He also skated in the IHL in 1993–1994.

RAY FERRARO, CENTER. Ferraro accumulated 898 points, 408 goals, and 1,288 PIM in 1,258 games during his 18 seasons in the NHL from 1984 to 2002. The center had a one-game stint with Capital District in 1992–1993 and had two assists and two PIM.

MARTY MCINNIS, LEFT WING. He accumulated 420 points, 250 assists, and 330 PIM in 796 games during his 12-year NHL career from 1991 to 2003. McInnis skated in 10 games with Capital District in 1992–1993 and tallied 16 points, 12 assists, and two PIM.

VLADIMIR MALAKHOV, DEFENSE. He produced 346 points, 260 assists, and 697 PIM in 712 games during his 13-year NHL career between 1992 and 2006. Malakhov had a three-game stint with Capital District in 1992–1993 and tallied 3 points, 2 goals, and 11 PIM. The defenseman skated with Stanley Cup–winning New Jersey in 1999–2000.

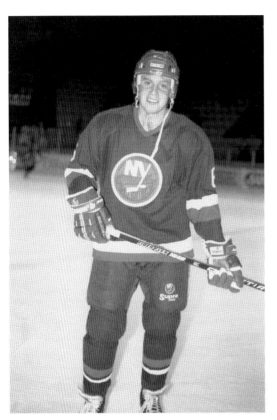

DENNIS VASKE, DEFENSE. Vaske garnered 51 points, 36 assists, and 194 PIM in 140 games during his three seasons with Capital District. He was a veteran of nine NHL seasons from 1990 to 1999 and produced 46 points, 41 assists, and 253 PIM in 235 games. The defenseman was selected in round two (No. 38 overall) of the 1986 NHL entry draft by the New York Islanders.

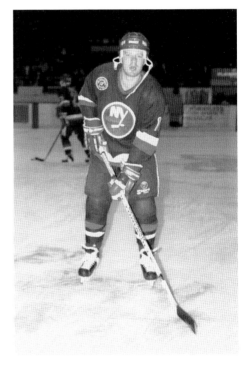

PHIL HUBER, CENTER. Huber played three seasons with Capital District and tallied 65 points, 37 assists, and 89 PIM in 92 games. The center also skated in the ECHL between 1990 and 1994, the IHL from 1993 to 1995, and the CoHL in 1994–1995. He was a member of the Canadian National Team in 1994–1995.

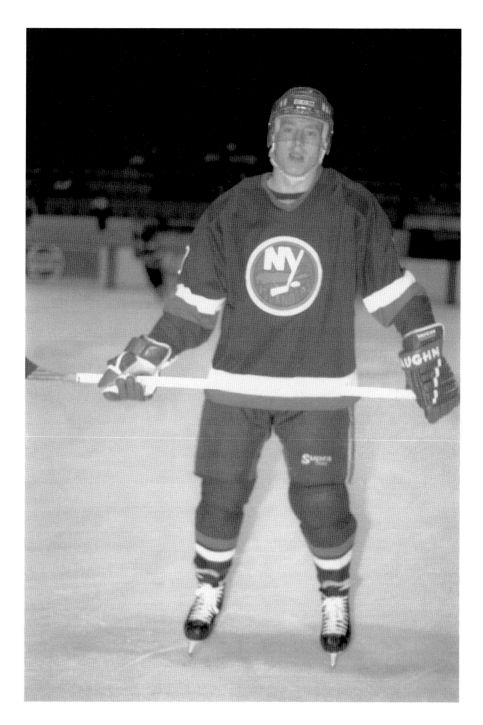

ALAN KERR, RIGHT WING. In 1990–1991, Kerr had 32 points, 21 assists, and 131 PIM in 43 games with the Islanders (AHL). A veteran of nine NHL seasons from 1984 to 1993, he produced 166 points, 94 assists, and 826 PIM in 391 games. The right-winger also skated in the AHL with Springfield from 1984 to 1986 and Moncton in 1992–1993.

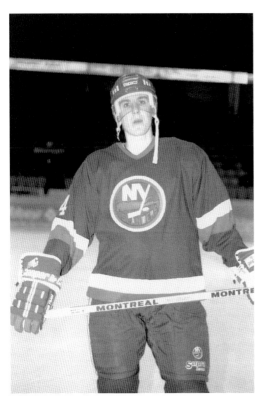

JARI GRONSTRAND, DEFENSE. In 1990–1991, the defenseman garnered 35 points, 22 assists, and 40 PIM in 63 games with the Islanders (AHL). A veteran of five NHL seasons from 1986 to 1991, Gronstrand tallied 34 points, 26 assists, and 135 PIM in 185 games. He also skated in the AHL with Halifax from 1988 to 1990 and had a stint with Calder Cup–winning Springfield in the 1989–1990 season.

BUTCH GORING, COACH. Goring won four consecutive Stanley Cups with the New York Islanders from the 1979–1980 season to the 1982–1983 season. He piloted Capital District during all three of the club's seasons and compiled a 94-114-32 (.458) record. He went on to coach in the NHL with Boston (1985–1987) and the New York Islanders (1999–2001) and earned an 83-130-27 (.402) record.

DAVE CHYZOWSKI, LEFT WING. Chyzowski was the New York Islanders' number-one pick (No. 2 overall) of the 1989 NHL entry draft. During his six NHL campaigns between 1989 and 1997, the left-winger garnered 144 PIM, 31 points, and 15 goals in 126 games. He spent three seasons with Capital District and produced 320 PIM, 78 points, and 45 assists in 128 games. Chyzowski also skated in the AHL with Calder Cup–winning Springfield in 1989–1990 and with Adirondack in 1995–1996.

DEAN CHYNOWETH, DEFENSE. He was the New York Islanders' number-one pick (No. 13 overall) of the 1987 NHL entry draft. Chynoweth tallied 667 PIM, 22 points, and 18 assists in 241 games during his nine seasons in the NHL between 1988 and 1998. The defenseman is Capital District's all-time penalty minute leader with 537 PIM. He also had 29 points and 21 assists in 139 games during his three seasons with the Islanders (AHL).

THE ISLANDERS PUT THEIR TOP FARM TEAM IN TROY

RICHARD KROMM, LEFT WING. Kromm is the Islanders' (AHL) all-time leader in assists (109) and games (231), and he is second all-time in points (164). He also tallied 55 goals and 82 PIM during his three seasons with Capital District. A veteran of nine NHL seasons between 1983 and 1993, the left-winger produced 173 points, 103 assists, and 138 PIM in 372 games. He later coached Muskegon (UHL) to a Colonial Cup championship in 1998–1999.

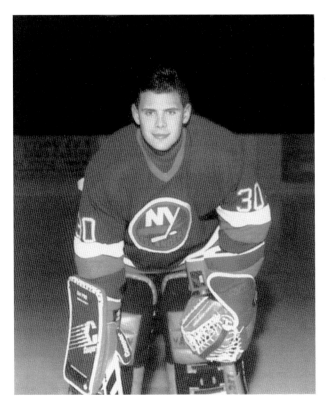

GEORGE MANELUK, GOALIE. In 1990–1991, he compiled a 4.06 GAA and a 10-14-1 record in 29 games with Capital District. Maneluk also played with the NHL Islanders that season and posted a 6.43 GAA and a 1-1-0 mark in four games. He was also between the pipes in the AHL with Springfield for several seasons between 1987 and 1994 and with New Haven in 1991–1992. Maneluk also played in the CHL, CoHL, ECHL, and IHL.

WAYNE MCBEAN, DEFENSE. He was Los Angeles' number-one (No. 4 overall) pick of the 1987 NHL entry draft. McBean produced 28 points, 18 assists, and 54 PIM in 42 games during his two seasons with the Islanders (AHL) in 1990–1991 and 1992–1993. The defenseman is a six-year NHL veteran between 1987 and 1994 and tallied 49 points, 39 assists, and 168 PIM in 211 games.

SCOTT SCISSONS, CENTER. Scissons was the New York Islanders' number-one (No. 6 overall) pick of the 1990 NHL entry draft. In the 1992–1993 season with Capital District, he produced 44 points, 30 assists, and 33 PIM in 43 games. The center had three stints in the NHL between 1990 and 1994. Scissons was a member of the Canadian National Team in 1991–1992.

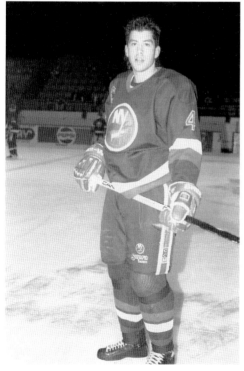

RICK HAYWARD, DEFENSE. The defenseman had 219 PIM, 12 points, and 9 assists in 46 games during his two campaigns with the Islanders (AHL) from 1991 to 1993. He had a four-game stint in the NHL in 1990–1991. Hayward skated for Turner Cup–winning Salt Lake City (IHL) in 1987–1988. He also played in the AHL with Sherbrooke from 1986 to 1988 and Moncton in 1992–1993.

HUBIE MCDONOUGH, CENTER.
McDonough garnered 47 points, 27 assists, and 18 PIM in 38 games with the Islanders (AHL) during his two seasons with the club from 1990 to 1992. A veteran of five NHL seasons from 1988 to 1993, the center produced 66 points, 40 goals, and 67 PIM in 195 games. He also skated in the AHL with New Haven from 1987 to 1989 and Manchester in 2001–2002.

DEAN TRBOYEVICH, DEFENSE. In 1991–1992 with Capital District, the defenseman had 65 PIM and three points in 22 games. Trboyevich skated in four other minor professional leagues—the ECHL in 1991–1992, the IHL between 1991 and 1998, the CoHL in 1995–1996, and the West Coast Hockey League (WCHL) between 1995 and 1999.

PAUL GUAY, RIGHT WING. In 1990–1991, Guay had 61 points, 26 goals, and 81 PIM in 74 games with Capital District. A veteran of seven NHL seasons between 1983 and 1991, the right-winger garnered 34 points, 23 assists, and 92 PIM in 117 games. He was a member of the 1984 U.S. Olympic Team and skated with the U.S. National Team during the 1983–1984 season.

GARY NYLUND, DEFENSE. Nylund was Toronto's number-one draft pick (No. 3 overall) of the 1982 NHL entry draft. The defenseman amassed 1,235 PIM, 171 points, and 139 assists in 608 games during his 11-year NHL career from 1982 to 1993. He played in six games over two seasons with Capital District from 1991 to 1993.

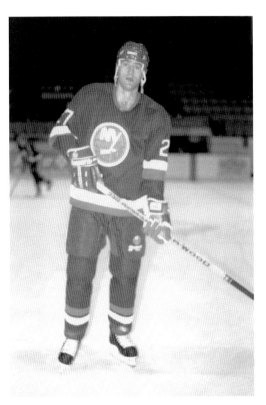

HANK LAMMENS, DEFENSE. In 1990–1991 with Capital District, the defenseman had five assists and 14 PIM in 32 games. Lammens played in the NHL in 1993–1994 and garnered three points, two assists, and 22 PIM in 27 games. He also skated in the AHL with Springfield from 1988 to 1990 and with Port Edward Island in 1993–1994. Lammens won a Calder Cup with Springfield in 1989–1990.

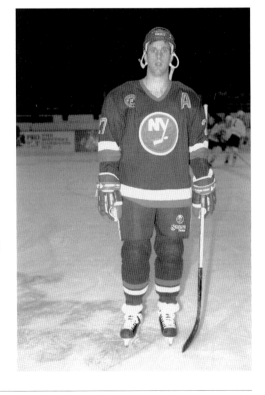

LEE GIFFIN, RIGHT WING. Giffin tallied 45 points, 26 assists, and 58 PIM in 77 games with Capital District in 1991–1992. He skated in two NHL seasons from 1986 to 1988 and had four points, three assists, and nine PIM in 27 games. The right-winger skated in the IHL from 1987 to 1991, the CoHL between 1992 and 1996, and the ECHL from 1996 to 1999. Giffin won a Turner Cup with Muskegon (IHL) in 1988–1989.

JEFF SHARPLES, DEFENSE. In 1991–1992 with Capital District, Sharples tallied 15 points, 12 assists, and 18 PIM in 31 games. A veteran of three NHL seasons from 1986 to 1989, the defenseman had 49 points, 35 assists, and 70 PIM in 105 games. He played for Calder Cup–winning Adirondack (AHL) in 1988–1989 and Turner Cup–winning Utah (IHL) in the 1995–1996 season.

WILL AVERILL, DEFENSE. He skated in 12 games with Capital District during his only season with the club in 1991–1992. Averill spent the rest of his professional career in the ECHL with Richmond from 1991 to 1993 and Roanoke in 1993–1994. The defenseman played four years of college hockey with Northeastern University from 1987 to 1991.

JIM CULHANE, DEFENSE. In his two seasons with the Islanders (AHL) from 1990 to 1992, Culhane garnered 72 PIM, four points, and three assists in 52 games. He had a stint in the NHL in 1989–1990 and had one point and four PIM in six games. He also played in the AHL with Binghamton from 1987 to 1990 and spent time in the IHL in 1990–1991.

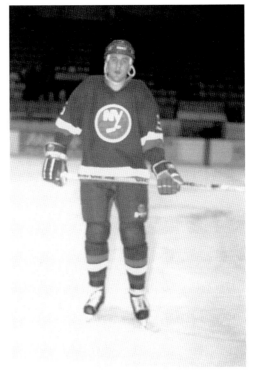

JEFF JABLONSKI, LEFT WING. In his three seasons with Capital District, the left-winger garnered 14 points, 7 goals, and six PIM in 54 games. Jablonski also skated in the IHL in 1990–1991 and the ECHL between 1991 and 1997. He was a member of Riley Cup–winning Toledo (ECHL) in 1992–1993.

JOHN BLUM, DEFENSE. A veteran of eight NHL seasons from 1982 to 1990, Blum tallied 610 PIM, 41 points, and 34 assists in 250 games. The defenseman played 51 games with the Islanders (AHL) in 1991–1992 and had 76 PIM and six points. He also skated in the AHL with Moncton (1982 to 1984 and 1985–1986), Maine (1987–1988 and 1989 to 1991), and Adirondack (1988–1989). Blum won a Calder Cup with Adirondack (AHL) in 1988–1989.

MICK VUKOTA, RIGHT WING. He stockpiled 2,071 PIM, 46 points, and 29 assists in 574 games during his 11 seasons in the NHL from 1987 to 1998. Vukota had a two-game stint with Capital District in 1990–1991 and collected nine PIM.

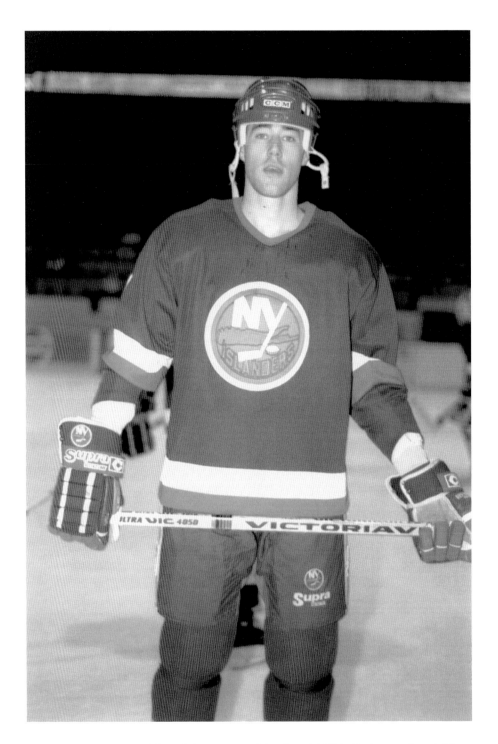

JEFF FINLEY, DEFENSE. The defenseman tallied 89 points, 72 assists, and 74 PIM in 148 games during his three seasons with the Islanders (AHL). Finley produced 83 points, 70 assists, and 457 PIM in 708 games during 15 NHL seasons between 1987 and 2004.

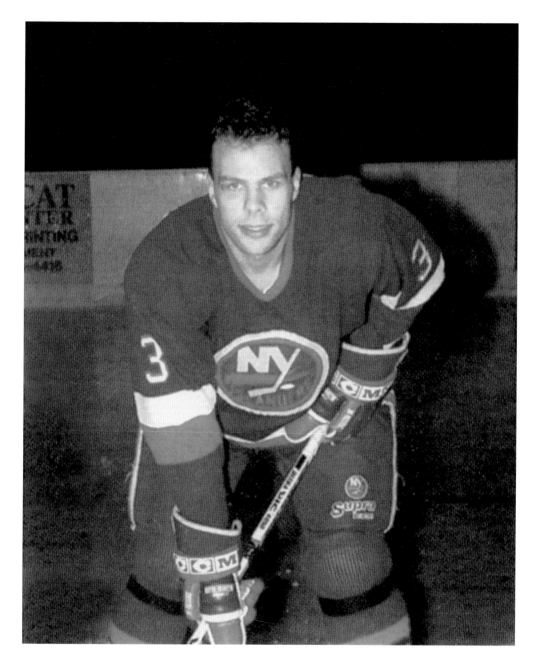

KEVIN CHEVELDAYOFF, DEFENSE. In his three seasons with the Islanders (AHL) from 1990 to 1993, the defenseman had 426 PIM, 29 points, and 26 assists in 199 games. Cheveldayoff set the Capital District single-season PIM mark with 203 in 1990–1991. He also played in the AHL with Calder Cup–winning Springfield in 1989–1990 and skated in the IHL with Salt Lake City in 1993–1994.

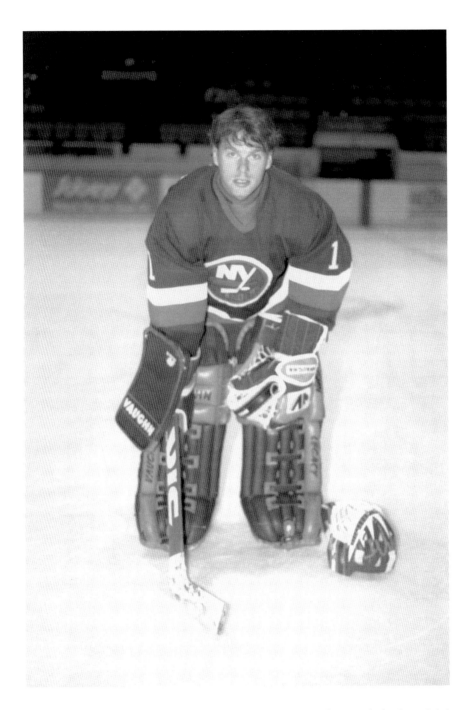

MARK FITZPATRICK, GOALIE. The goaltender was the winner of the NHL's Bill Masterton Memorial Trophy in 1991–1992 for perseverance, sportsmanship, and dedication to hockey. In his 12 NHL seasons from 1988 to 2000, Fitzpatrick compiled a 3.12 GAA and a 113-136-49 record in 329 games. He posted a 3.47 GAA and a 10-15-4 record in 31 games during his three seasons with Capital District.

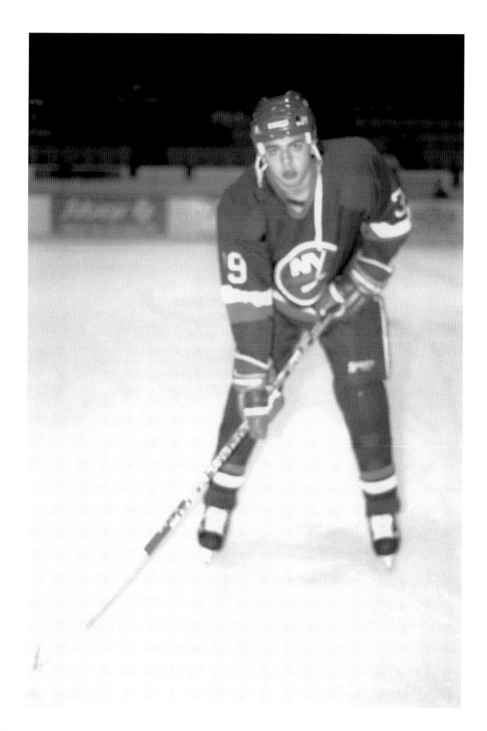

TRAVIS GREEN, CENTER. The center ranks third all-time in goals (56) in Capital District history. He tallied 128 points, 72 assists, and 75 PIM in 164 games during his three seasons with the Islanders (AHL). The 13-year NHL veteran, between 1992 and 2006, garnered 452 points, 191 goals, and 737 PIM in 939 games.

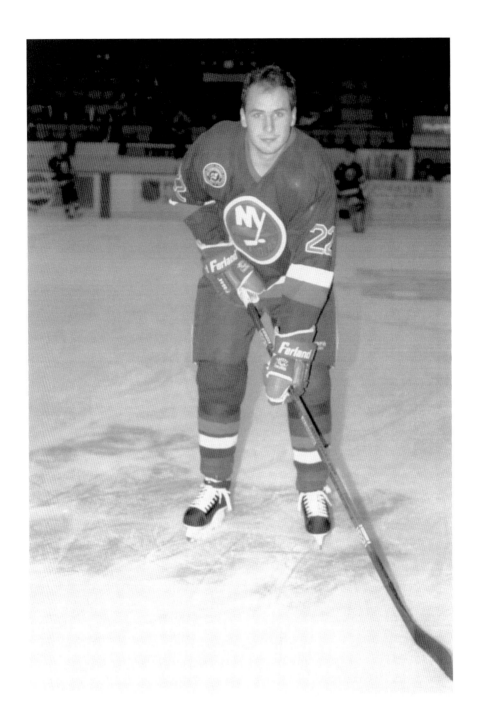

BRENT GRIEVE, LEFT WING. Grieve is Capital District's all-time leader in goals (82). He also ranks second in games (214) and third in points (155) on the Islanders' (AHL) all-time list. The left-winger had 73 assists and 286 PIM in 214 games during his three seasons with Capital District. In his four NHL seasons from 1993 to 1997, Grieve had 36 points, 20 goals, and 87 PIM in 97 games.

THE ISLANDERS PUT THEIR TOP FARM TEAM IN TROY

TOM FITZGERALD, RIGHT WING. He was the New York Islanders' number-one draft pick (No. 17 overall) of the 1986 NHL entry draft. A veteran of 17 NHL seasons between 1988 and 2006, Fitzgerald tallied 329 points, 190 assists, and 776 PIM in 1,097 games. The right-winger played two seasons with Capital District from 1990 to 1992 and had 16 points, 8 goals, and 54 PIM in 31 games.

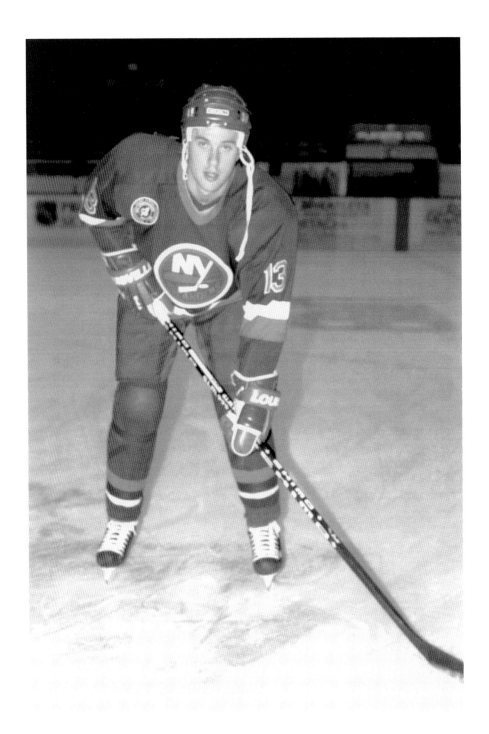

Sean LeBrun, Left Wing. LeBrun produced 73 points, 48 assists, and 75 PIM in 109 games during his three seasons with Capital District. He was selected by the New York Islanders in round two (No. 37 overall) of the 1988 NHL entry draft. The left-winger won a Calder Cup with Springfield in 1989–1990 and also skated in the ECHL from 1991 to 1993.

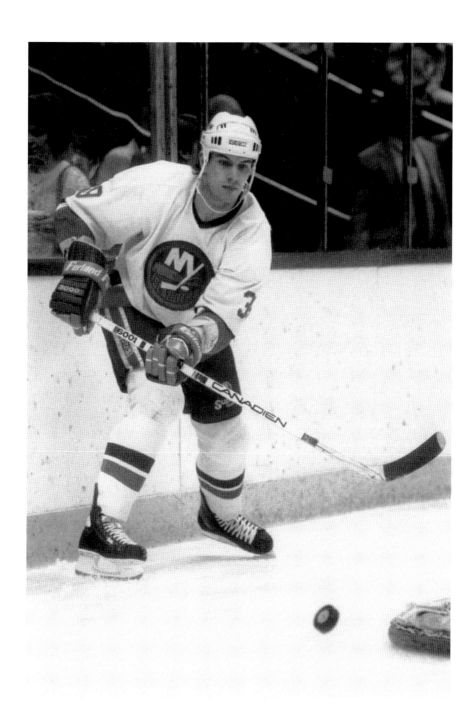

MARC BERGEVIN, DEFENSE. Bergevin is a veteran of 20 NHL seasons from 1984 to 2004. He amassed 1,090 PIM, 181 points, and 145 assists in 1,191 NHL games. In 1990–1991, the defenseman tallied five points on five assists and had six PIM in seven games with the Islanders (AHL). He won back-to-back Calder Cups with Springfield (AHL) in 1989–1990 and 1990–1991.

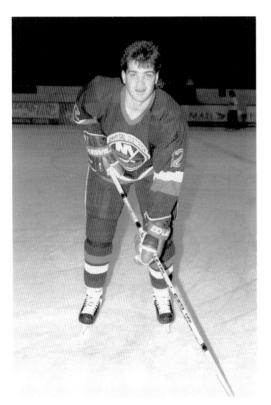

CHRIS TAYLOR, CENTER. Taylor skated for three playoff championship teams. He played for Turner Cup–winning teams with Denver (IHL) in 1994–1995 and Utah (IHL) in 1995–1996, and for Calder Cup–winning Providence (AHL) in 1998–1999. The center had 62 points and 19 goals in 77 games with Capital District in 1992–1993. A veteran of eight NHL seasons between 1994 and 2004, Taylor had 32 points and 21 assists in 149 games.

DEAN EWEN, LEFT WING. In two seasons with the Islanders (AHL) from 1991 to 1993, Ewen produced 18 points, 11 assists, and 166 PIM in 66 games. The left-winger also skated in the AHL with Springfield from 1988 to 1990, including playing for the 1989–1990 Springfield Calder Cup–winning team. Ewen also played in the IHL from 1993 to 1999 and the WCHL in the 1999–2000 season.

CHRIS PRYOR, DEFENSE. Pryor was the Islanders (AHL) assistant coach during all three of the club's seasons. The defenseman compiled 12 points, 11 assists, and 112 PIM in 66 games during his career with Capital District. A veteran of six NHL seasons, Pryor had 5 points, 4 assists, and 122 PIM in 82 games.

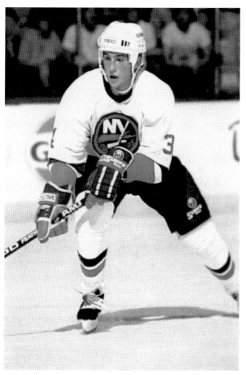

ROB DiMAIO, RIGHT WING. A veteran of 17 NHL seasons between 1988 and 2006, DiMaio produced 277 points, 171 assists, and 840 PIM in 894 games. The right-winger played 12 games with Capital District in 1990–1991 and had seven points, four assists, and 22 PIM. He also skated in the AHL with Springfield from 1988 to 1990 and Utah in 2001–2002. DiMaio won a Calder Cup with Springfield (AHL) in 1989–1990.

IAIN FRASER, CENTER. Fraser set the Islanders' (AHL) single-season records for points (110), goals (41), and assists (69) in 1992–1993. He ranks third all-time in assists (93) in Capital District history. He also tallied 148 points, 55 goals, and 56 PIM in 151 games during his three seasons with the Islanders (AHL). The center skated in five NHL campaigns from 1992 to 1997 and tallied 46 points, 23 goals, and 31 PIM in 94 games.

BILL BERG, DEFENSE. The 10-year
NHL veteran (between 1988 and 1999)
accumulated 488 PIM, 122 points, and 67
assists in 546 games. Berg had a three-game
stint with Capital District in 1991–1992,
produced two points on two assists, and
had 16 PIM. The defenseman also spent
time in the AHL with Springfield from
1986 to 1990 and Hartford in 1998–1999.
Berg won a Calder Cup with Springfield
(AHL) in 1989–1990.

GRAEME TOWNSHEND, RIGHT WING. He
produced 87 points, 43 goals, and 139 PIM
in 128 games during his two campaigns with
the Islanders (AHL) from 1991 to 1993. A
veteran of five NHL seasons from 1989 to
1994, the right-winger had 10 points, seven
assists, and 28 PIM in 45 games. Townshend
was the IHL Man of the Year in 1995–1996
with Houston and the WPHL Man of the
Year in 1998–1999 with Lake Charles.

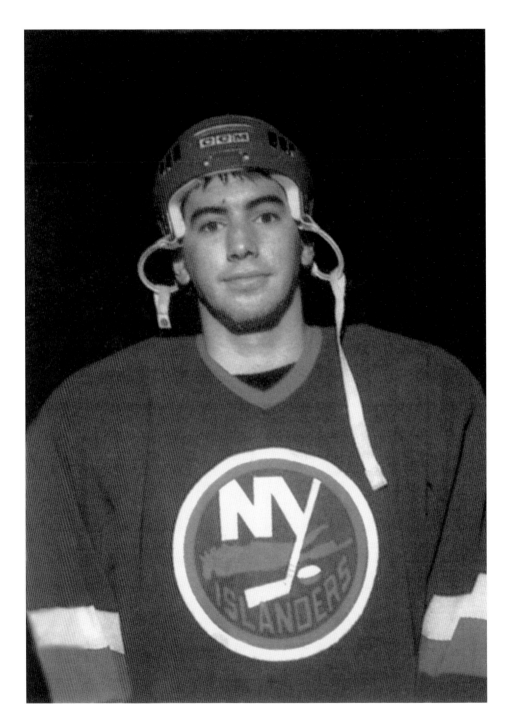

WAYNE DOUCET, LEFT WING. In his three seasons with the Islanders (AHL), Doucet accumulated 364 PIM, 62 points, and 33 goals in 153 games. The left-winger also skated in the AHL with Springfield in 1988–1989 and Moncton in 1993–1994 and spent time in the IHL from 1993 to 1995 and the CoHL in 1994–1995.

THE ISLANDERS PUT THEIR TOP FARM TEAM IN TROY

5

THE RIVER RATS
BRING THE CALDER
CUP TO ALBANY

The Albany River Rats were born into the American Hockey League (AHL) in 1993–1994 out of a series of events that occurred between two other AHL teams prior to the organization of the Albany team. The New Jersey Devils' (NHL) AHL affiliate the Utica Devils (members of the AHL from 1987 to 1993) continued to lose money season after season, and New Jersey wanted to move the AHL franchise. According to Devils (NHL) GM Lou Lamoriello, the money losses in Utica were so great that New Jersey no longer wanted to own a minor-league franchise.

In May, the Devils (NHL) sold the Utica (AHL) franchise to the Calgary Flames (NHL), who decided to operate it out of Saint John, New Brunswick, as the Saint John Flames. New Jersey then established a working agreement with the Capital District Islanders (AHL) franchise. Capital District had just lost its affiliation with the New York Islanders (NHL), and Capital District team owner Albert Lawrence was ready to sign a deal that was highly favorable to any NHL team. Lawrence moved the Capital District (AHL) franchise from Troy to Albany's Knickerbocker Arena and renamed the team the Albany River Rats.

The River Rats were coached by Robbie Ftorek, who piloted the Devils' (NHL) top farm team in Utica during the previous year. Albany compiled a 38-34-8 record in its first season in 1993–1994 and finished in third place out of five in its division. In the playoffs, the River Rats lost in the first round to the Portland Pirates four games to one. Bill Armstrong led the team in points (82), Jason Miller had the most assists (53), while Jeff Christian tallied the most goals (34). Corey Schwab handled the bulk of the goaltending duties that season, appearing in 51 games with a 3.61 GAA and a 27-21-3 record.

In the 1994–1995 season, Albany won the Calder Cup title in only its second season. The River Rats also won the AHL's regular-season title and captured its first division title with a 46-17-17 record good for 109 points. Robbie Ftorek won the AHL's Louis A. R. Pieri Memorial Award as coach of the year, while Corey Schwab (a 2.59 GAA and a 25-10-9 record in 45 games) and Mike Dunham (a 2.80 GAA and a 20-7-8 record in 35 games) shared the AHL's Harry "Hap" Holmes Memorial Award as outstanding team goaltenders. Kevin Dean (first team defense) and Corey Schwab (second team) were named AHL all-stars. The River Rats skated through the postseason with a 12-2 record to capture the Calder Cup championship. Albany swept the Adirondack Red Wings in four games in the opening round and then beat the Providence Bruins four games to two. After receiving a bye into the finals, Albany won four in

a row against the Fredericton Canadiens. Corey Schwab and Mike Dunham were awarded the Jack Butterfield Trophy as playoff co-MVPs.

In the 1995–1996 season, it appeared as though the River Rats were going to repeat as the club achieved the second-highest regular-season point total in AHL history (115) and tied for the second most regular season wins (54) in league history on their way to a second AHL regular-season championship and division title. Albany set an AHL record for the longest road winning streak in league history (13 games) and compiled an all-time team high 21-game unbeaten streak (19-0-2) that season. Ftorek was again selected as AHL coach of the year as he led the club to a 54-19-7 record. Steve Sullivan (first team center), Mike Dunham (second team goalie), and Brad Bombardir (second team defense) were named to the AHL all-star team. Albany's regular-season success was not carried into the playoffs, however, as they were upset in the first round by the Cornwall Aces three games to one.

ROBBIE FTOREK, COACH. He coached the River Rats for six seasons (1993 to 1996 and 2003 to 2006) and led the club to a Calder Cup title in 1994–1995, two AHL regular-season titles in 1994–1995 and 1995–1996, and two division titles in 1994–1995 and 1995–1996. Ftorek compiled a 199-197-32 (.533 which includes 26 points from overtime/shootout losses) record with Albany. He is the last coach to win the AHL's Louis A. R. Pieri Memorial Award as coach of the year in consecutive seasons in 1994–1995 and 1995–1996. As a player, the center spent eight years in the NHL between 1972 and 1985, tallying 227 points and 150 assists in 334 games. In five WHA seasons from 1974 to 1979, he collected 523 points and 216 goals in 373 games. He was inducted into the U.S. Hockey Hall of Fame in 1991.

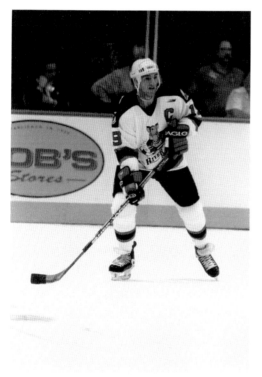

STEVE BRULE, RIGHT WING. Brule is the River Rats' all-time leader in points (369), goals (155), and assists (214). He also had 151 PIM in 395 games during his six seasons with Albany from 1994 to 2000. The right-winger was a member of Albany's Calder Cup team. He had two stints in the NHL in 1999–2000 and 2002–2003. Brule set the River Rats' single-season record for power-play goals with 20 in 1997–1998.

THE 1994–1995 CALDER CUP CHAMPION RIVER RATS. The Albany River Rats gave the Capital District its first professional hockey championship when they captured the AHL's Calder Cup title in 1994–1995. In the process of winning the league's playoff championship, the River Rats also won the AHL regular-season and the team's first division title. Right-winger Steve Sullivan led the River Rats in points (81) and assists (50), while right-winger Rob Conn led the team in goals (35) during the regular season. The bulk of the goaltending

duties were split between Corey Schwab (a 2.59 GAA and a 25-10-9 record in 45 games) and Mike Dunham (a 2.80 GAA and a 20-7-8 record in 35 games). Corey Schwab and Mike Dunham shared the AHL's Harry "Hap" Holmes Memorial Award as outstanding team goaltenders during the regular season. Robbie Ftorek won the AHL's Louis A. R. Pieri Memorial Award as coach of the year.

BEN HANKINSON, RIGHT WING. The right-winger had 24 points, 14 assists, and 86 PIM in 30 games during his two seasons with Albany from 1993 to 1995. A veteran of three NHL campaigns from 1992 to 1995, he registered 45 PIM, six points, and three goals in 43 games. Hankinson also skated in the AHL with Utica from 1991 to 1993 and Adirondack in 1995–1996. He had a stint with Stanley Cup–winning New Jersey in 1994–1995.

STEVE SULLIVAN, RIGHT WING. Sullivan is eighth all-time in goals (72), eighth all-time in points (171), and ninth all-time in assists (99) in River Rats history. He also had 267 PIM in 143 games during his three seasons with Albany from 1994 to 1997. The right-winger led the River Rats in points (81) during the team's Calder Cup championship season. A veteran of 10 NHL seasons between 1995 and 2006, he had 517 points and 206 goals in 666 games.

BRAD BOMBARDIR, DEFENSE. The defenseman was a member of the River Rats' Calder Cup–winning team. He had 66 points, 55 assists, and 91 PIM in 194 games during his four seasons with Albany from 1994 to 1998. Bombardir is a veteran of seven NHL seasons from 1997 to 2004. He registered 54 points, 46 assists, and 127 PIM in 356 NHL games and was a member of New Jersey's 1999–2000 Stanley Cup–winning team.

BILL ARMSTRONG, LEFT WING. Armstrong is 10th all-time in goals (67), 7th all-time in assists (101), and 9th all-time in points (168) in River Rats history. From 1993 to 1996 with Albany, he also had 325 PIM in 160 games. The left-winger was a member of the River Rats' Calder Cup–winning team. He had a stint in the NHL with Philadelphia in 1990–1991. Armstrong scored the first goal in River Rats history.

MATT RUCHTY, LEFT WING. He set the team record for PIM in a season with 348 during the River Rats' Calder Cup championship season. In all, Ruchty compiled 785 PIM, 83 points, and 40 assists in 175 games in three years with Albany (1993 to 1995 and 1998–1999). The left-winger also skated in the AHL with Utica from 1991 to 1993, Syracuse in 1995–1996, Rochester in 1997–1998, and Providence in 1998–1999.

MIKE DUNHAM, GOALIE. Dunham is third all-time in career GAA (2.84) and third all-time in wins (53) in River Rats history. He compiled a 53-20-12 record in 87 games during his four seasons with Albany from 1993 to 1997. The goalie shared the Harry "Hap" Holmes Memorial Award as outstanding team goaltender and the Jack Butterfield Trophy as playoff co-MVP during the River Rats' Calder Cup–winning season. Dunham compiled a 2.69 GAA and a 137-168-41 record in 375 NHL games from 1996 to 2004. He shared the NHL's William M. Jennings Trophy (fewest goals against) in 1996–1997.

BRIAN ROLSTON, CENTER/RIGHT WING. Rolston skated for two New Jersey Stanley Cup–winning teams in 1994–1995 and 1999–2000 and was the franchise's number-two pick (No. 11 overall) of the 1991 NHL entry draft. In his 11 NHL seasons between 1994 and 2006, he produced 511 points, 287 assists, and 273 PIM in 818 games. A member of the River Rats' Calder Cup team, he had 30 points and 16 assists during two seasons with Albany from 1993 to 1995.

KRZYSZTOF OLIWA, LEFT WING. Oliwa accumulated 767 PIM, 51 points, and 30 assists in 164 games with the River Rats from 1993 to 1997. The left-winger was a member of Albany's Calder Cup–winning team. In nine NHL seasons between 1996 and 2006, Oliwa amassed 1,447 PIM, 45 points, and 28 assists in 410 games. He was a member of New Jersey's 1999–2000 Stanley Cup–winning team.

MIKE VUKONICH, CENTER. Vukonich played for the River Rats during their Calder Cup championship season. In his two campaigns with Albany from 1994 to 1996, he had 30 points, 16 goals, and 16 PIM in 62 games. The center also skated in the IHL between 1991 and 1999, the CoHL in 1993–1994, and the ECHL in 1995–1996.

DEAN MALKOC, DEFENSE. In two seasons with Albany from 1993 to 1995, Malkoc accumulated 348 PIM and 10 points on 10 assists in 88 games. The defenseman is a veteran of four NHL seasons from 1995 to 1999, registering 299 PIM, four points, and three assists in 116 games. He also played in the AHL with Utica from 1990 to 1993, Providence in 1996–1997, Lowell in 1998–1999, and Cincinnati in 2000–2001.

DENIS PEDERSON, CENTER/RIGHT WING. He was New Jersey's number-one pick (No. 13 overall) of the 1993 NHL entry draft. In his two regular seasons with Albany from 1995 to 1997, the forward registered 75 points, 46 assists, and 111 PIM in 71 games. Pederson also played for the River Rats during the 1994–1995 postseason. A veteran of eight NHL seasons from 1995 to 2003, he had 128 points and 71 assists in 435 games. He was a member of New Jersey's 1999–2000 Stanley Cup–winning team.

SCOTT PELLERIN, LEFT WING. Pellerin is tied for fourth all-time in goals (86), tied for fourth all-time in points (212), and is fifth all-time in assists (126) in River Rats history. He also accumulated 321 PIM in 222 games during his three seasons with Albany from 1993 to 1996. A veteran of 11 NHL seasons between 1992 and 2004, the 1991–1992 Hobey Baker Award winner (NCAA Division I MVP) had 198 points and 126 assists in 536 NHL games.

BRYAN HELMER, DEFENSE. Helmer is third all-time in assists (161) and tied for fourth all-time in points (212) in River Rats history. He also accumulated 501 PIM and 51 goals in 379 games during his five seasons with Albany from 1993 to 1998. In his six NHL seasons from 1998 to 2004, the defenseman produced 23 points, 15 assists, and 133 PIM in 134 games. He also played in the AHL with four other teams between 1998 and 2006.

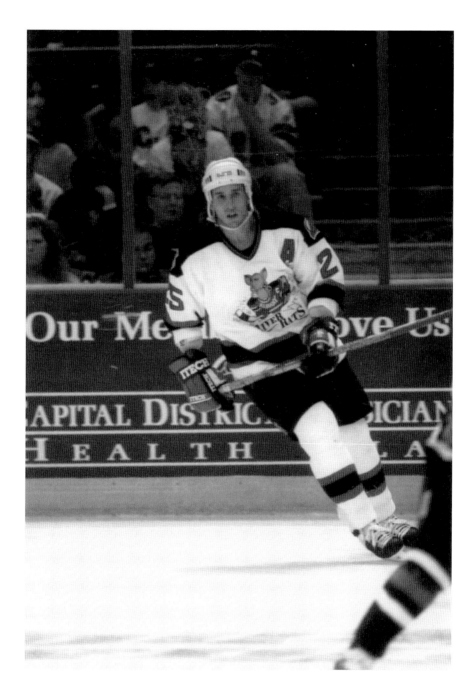

PASCAL RHEAUME, CENTER. Rheaume is second all-time (110) in goals, second all-time in points (243), and fourth all-time in assists (133) in River Rats history. During his six seasons with Albany (1993 to 1997 and 2004 to 2006), the center also had 273 PIM in 339 games. He won a Calder Cup with the River Rats in 1994–1995 and a Stanley Cup with New Jersey in 2002–2003. In his nine NHL seasons between 1996 and 2006, he had 91 points and 52 assists in 318 games.

THE RIVER RATS CELEBRATE WINNING THE 1994–1995 CALDER CUP CHAMPIONSHIP. The River Rats captured the Calder Cup championship by defeating the Fredericton Canadiens in the playoff finals four games to none. Albany compiled a 12-2 postseason record that year, also sweeping the Adirondack Red Wings four games to none in the first round of the playoffs and then defeating the Providence Bruins four games to two in the

second round. Left-winger Matt Ruchty led the River Rats in points (15) and in assists (10) that postseason, while right-winger Steve Brule led the team in goals (9). Mike Dunham and Corey Schwab split the goaltending duties in the playoffs, each going 6-1 in seven games, and were awarded the Jack Butterfield Trophy as playoff co-MVPs.

GEORDIE KINNEAR, DEFENSE. Kinnear played the second most games (406) and amassed the second most PIM (1,094) in River Rats history. In his seven years with Albany (1993 to 1999 and 2000–2001), the defenseman also produced 85 points and 68 assists. He was a member of the River Rats' Calder Cup–winning team and was an assistant coach with Albany from 2001 to 2004 and in 2005–2006.

KEVIN DEAN, DEFENSE. Dean skated in five seasons with Albany from 1993 to 1998 and produced 87 points, 72 assists, and 166 PIM in 143 games. A veteran of seven NHL seasons from 1994 to 2001, the defenseman had 55 points, 48 assists, and 138 PIM in 331 games. He was a member of the River Rats' Calder Cup–winning team and skated with New Jersey's Stanley Cup–winning team during the 1994–1995 season.

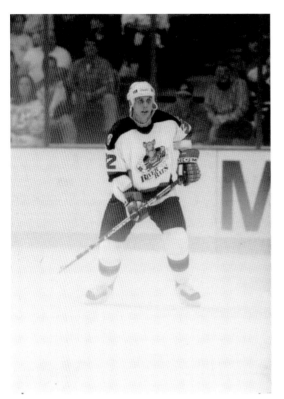

CALE HULSE, DEFENSE. A veteran of 10 NHL seasons between 1995 and 2006, Hulse amassed 1,000 PIM, 95 points, and 79 assists in 619 games. During his three seasons with Albany from 1993 to 1996, the defenseman accumulated 508 PIM, 66 points, and 50 assists in 198 games. Hulse was a member of the River Rats' Calder Cup championship team. He also played in the AHL with Saint John in 1995–1996.

ROB CONN, RIGHT WING, RAISES THE CALDER CUP. In his only season with the River Rats in 1994–1995, he had 67 points, 35 goals, and 76 PIM in 68 games. Conn led Albany in goals that Calder Cup–winning season. The right-winger skated in two NHL seasons (1991–1992 and 1995–1996) and registered seven points, five assists, and 20 PIM in 30 games. He holds the River Rats' single-season record for game-winning goals with 10 in 1994–1995.

JASON SMITH, DEFENSE. New Jersey's number-one pick (No. 18 overall) of the 1992 NHL entry draft, Smith accumulated 863 PIM, 147 points, and 110 assists in 786 games during his 12 NHL seasons between 1993 and 2006. The defenseman played 27 games with Albany from 1993 to 1995 and registered 11 points, 6 goals, and 46 PIM.

RICARD PERSSON, DEFENSE. Persson came to the River Rats during their Calder Cup championship playoff run. During the next two regular seasons with Albany from 1995 to 1997, he had 51 points, 35 assists, and 67 PIM in 80 games. A veteran of seven NHL seasons from 1995 to 2002, the defenseman had 262 PIM, 54 points, and 44 assists in 229 games. He also skated in the AHL with Worcester from 1997 to 2000.

COREY SCHWAB, GOALIE. Schwab shared the Jack Butterfield Trophy as playoff co-MVP and the Harry "Hap" Holmes Memorial Award (outstanding team goaltender) during the River Rats' Calder Cup championship season. In his three years with Albany from 1993 to 1996, he recorded a 3.10 GAA in 101 games and has the second most wins all-time with Albany with a 55-33-12 record. Schwab registered the first shutout in River Rats history against Springfield (2-0) on October 7, 1994. A veteran of eight NHL seasons between 1995 and 2004, he compiled a 2.89 GAA and a 42-63-13 record in 147 games.

CHAD ERICKSON, GOALIE. He posted a 3.70 GAA and a 3-1-0 record in five games with Albany during his two seasons with the club from 1993 to 1995. Erickson had a stint in the NHL with New Jersey in 1991–1992 and compiled a 4.50 GAA and a 1-1-0 record in two games. The goalie was also between the pipes in the AHL with Utica from 1991 to 1993, Providence in 1994–1995, and Springfield in 1994–1995.

REID SIMPSON, LEFT WING. A veteran of 12 NHL seasons between 1991 and 2004, Simpson amassed 838 PIM, 36 points, and 18 goals in 301 games. In his four campaigns with the River Rats from 1993 to 1997, Simpson accumulated 430 PIM, 61 points, and 33 assists in 116 games. He was a member of Albany's Calder Cup championship team and skated for New Jersey's 1994–1995 Stanley Cup–winning team.

SHELDON SOURAY, DEFENSE. In seven NHL seasons between 1997 and 2006, the defenseman registered 686 PIM, 121 points, and 81 assists in 425 games. Souray skated in four campaigns with the River Rats from 1994 to 1998 and had 188 PIM, 17 points, and 15 assists in 89 games. He had a stint with Albany during their Calder Cup championship season and was a member of New Jersey's 1999–2000 Stanley Cup–winning team.

SERGEI BRYLIN, LEFT WING. Brylin is the only River Rat to play for all three New Jersey Stanley Cup–winning teams. A veteran of 11 NHL seasons between 1994 and 2006, the left-winger produced 252 points, 145 assists, and 218 PIM in 601 games. Brylin had 138 points, 57 goals, and 176 PIM in 150 games during his three years with Albany in 1994–1995 and from 1996 to 1998. Brylin was a member of the River Rats' Calder Cup team.

Albany Continues to Develop Future NHL Talent

John Cunniff became the River Rats' new coach in 1996–1997, and the club finished in third place in their division with a 38-33-9 record. In the postseason, Albany almost made it back to the finals. The River Rats defeated Adirondack three games to one and then the Rochester Americans four games to three during the first two rounds of the playoffs. In the semifinals, the Hamilton Bulldogs stopped the locals four games to one.

In the 1997–1998 season, Albany won its third division crown with a 43-26-11 mark. Bryan Helmer (first team defense) and Rich Shulmistra (tied for a second team goalie slot) were named AHL all-stars. Brendan Morrison was selected to the AHL's all-rookie team as a forward. The River Rats experienced success in the playoffs and were again one step away from another finals appearance. The locals swept through the first two playoff rounds by winning seven consecutive games, defeating Adirondack in three straight and then Hamilton in four straight. In the semifinals, Albany lost to the Philadelphia Phantoms four games to two.

The River Rats achieved their sixth straight winning season in 1998–1999 with a 46-28-6 record and a second-place finish in their division. Defenseman Ken Sutton was given the AHL's Eddie Shore Award as outstanding defenseman and was named a first team all-star. Left-winger Jeff Williams was selected to the second all-star team. In the postseason, Albany lost in the first round to Hamilton three games to two.

In the 1999–2000 season, Albany suffered its first sub-.500 season with a 30-43-7 mark, finishing fourth out of five in its division. The record was good enough for a playoff spot, but Cunniff's club again had an early postseason exit, losing to Rochester in the first round, three games to two.

The River Rats failed to make the postseason for the first time in franchise history in 2000–2001, finishing with a 30-44-6 record and in last place in their division. It was Cunniff's last season behind the bench for Albany. A season highlight was left-winger Pierre Dagenais being selected to the AHL's second all-star team.

For the 2001–2002 season, Bobby Carpenter was named Albany's new coach. The team, however, endured their worst season ever, with a 14-54-12 record and a last place finish in its division. The following season, Dennis "Red" Gendron piloted the River Rats and did not fare much better with a 25-44-11 record and another last place finish. Defenseman Ray Giroux (first team) and center Craig Darby (second team) were named to the AHL all-star squad in 2002–2003.

In the 2003–2004 season, Red Gendron was replaced midseason by Robbie Ftorek, but the team remained in the division basement with a 21-48-11 mark. In Ftorek's first full season back behind the bench in 2004–2005, the River Rats improved slightly with a 29-51 (wins-losses) record but failed to make the playoffs for the fifth straight season.

The River Rats slipped to a 25-55 (wins-losses) record in 2005–2006 under Ftorek and failed to qualify for the playoffs for an AHL all-time record sixth consecutive season. It would be the River Rats' last season as the New Jersey Devils' top affiliate. During the 2006–2007 season, Albany will be the AHL affiliate of both the Carolina Hurricanes (NHL) and the Colorado Avalanche (NHL).

JOHN CUNNIFF, COACH. Cunniff coached the River Rats for five campaigns from 1996 to 2001. He led Albany to a division title and compiled a 187-174-39 (.541 which includes 20 points from overtime losses) record. He was inducted into the U.S. Hockey Hall of Fame in 2003 under the coaches category. In three seasons in the WHA between 1972 and 1976, the left-winger tallied 20 points and 10 goals in 65 games. Cunniff coached in the NHL with Hartford in 1982–1983 and New Jersey from 1989 to 1991.

COLIN WHITE, DEFENSE. White was a member of two Stanley Cup–winning teams with New Jersey in 1999–2000 and 2002–2003. He had 613 PIM, 71 points, and 56 assists in 396 games during his six seasons with the Devils (NHL) between 1999 and 2006. The defenseman accumulated 676 PIM, 56 points, and 46 assists in 205 games with Albany from 1997 to 2000.

PATRIK ELIAS, LEFT WING. Elias won two Stanley Cups with New Jersey in 1999–2000 and 2002–2003. A veteran of 10 seasons with the Devils (NHL) between 1995 and 2006, Elias produced 504 points, 223 goals, and 295 PIM in 596 games. In his years with the River Rats from 1995 to 1998, the left-winger contributed 133 points, 54 goals, and 161 PIM in 134 games.

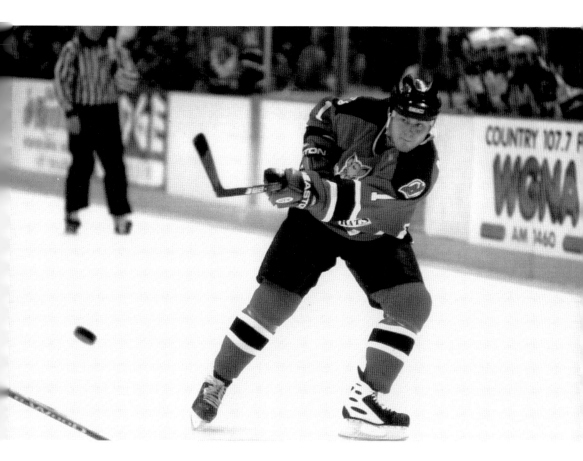

JOHN MADDEN, CENTER. Madden is 10th all-time in assists (96) in River Rats history. He also produced 154 points and 58 goals in 149 games with Albany from 1997 to 1999. The center was a member of New Jersey Stanley Cup–winning teams in 1999–2000 and 2002–2003. He garnered 199 points and 101 goals in 482 NHL games between 1998 and 2006. Madden was the NHL's Frank J. Selke Trophy winner (best defensive forward) in 2000–2001.

PETER ZEZEL, CENTER. The center had 608 points, 219 goals, and 435 PIM in 873 games during his 15 NHL seasons from 1984 to 1999. In his only season with Albany in 1997–1998, Zezel had 50 points, 37 assists, and 18 PIM in 35 games.

STANISLAV GRON, LEFT WING. The left-winger had 82 points, 48 goals, and 70 PIM in 202 games during his three seasons with Albany from 1999 to 2002. Gron had a stint in the NHL with New Jersey in 2000–2001. He also skated in the IHL in 1998–1999.

DAVID MALEY, LEFT WING. He amassed 1,043 PIM, 124 points, and 81 assists in 466 games during nine NHL seasons from 1985 to 1994. In the 1999–2000 season, the left-winger registered 52 PIM, 15 points, and 10 assists in 60 games with the River Rats. Maley also skated in the AHL with Sherbrooke in 1986–1987 and Utica in 1987–1988.

MIKE BUZAK, GOALIE. Buzak compiled the second-lowest career GAA (2.72) for the River Rats. From 1998 to 2000 with Albany, he also posted a 25-22-5 record in 62 games. The goaltender shared the IHL's James Norris Memorial Trophy (outstanding goaltender) in 1997–1998. Buzak also spent time in the ECHL during the 1996–1997 and 1999–2000 seasons and in the WCHL in 1997–1998 and from 2000 to 2003.

Sylvain Cloutier, Center. In his four seasons with the River Rats (1999 to 2002 and 2003–2004), the center had 110 points, 73 assists, and 331 PIM in 207 games. Cloutier had a stint in the NHL in 1998–1999. He also skated in the AHL with Adirondack from 1993 to 1998, Houston in 2002–2003, and Syracuse in 2003–2004. The center spent time in the ECHL in 1995–1996, the IHL from 1997 to 2000, and the UHL from 2003 to 2006.

KEN SUTTON, DEFENSE. Sutton is sixth all-time in assists (104) in River Rats history. He also garnered 134 points and 411 PIM in 277 games during his five seasons with the River Rats (1996 to 2000 and 2002–2003). He won the AHL's Eddie Shore Award (outstanding defenseman) in 1998–1999. A veteran of 11 NHL seasons between 1990 and 2002, the defenseman garnered 103 points, 80 assists, and 338 PIM in 388 games.

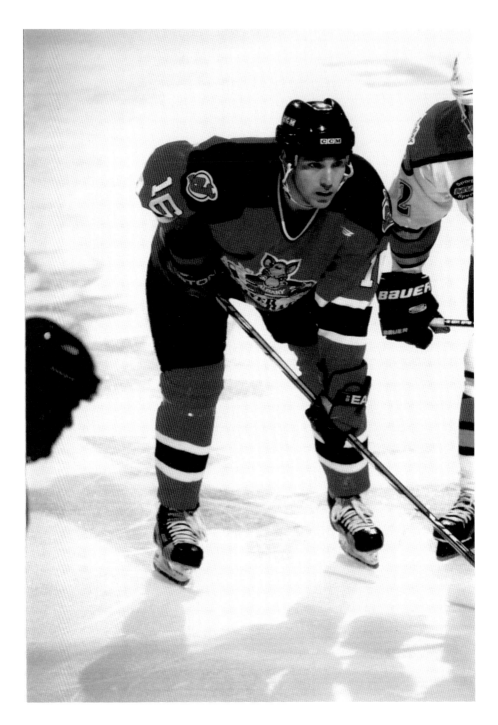

JEFF WILLIAMS, LEFT WING. Williams is third all-time in goals (101) and seventh all-time in points (180) in River Rats history. During his four years with Albany from 1996 to 2000, the left-winger also had 79 assists and 95 PIM in 249 games. Williams set the River Rats' single-season record for goals with 46 in 1998–1999.

JEAN-FRANCOIS DAMPHOUSSE, GOALIE. He was New Jersey's number-one pick (No. 24 overall) of the 1997 NHL entry draft. Damphousse earned a 2.95 GAA and a 36-46-7 record in 100 games during his four seasons with Albany from 1998 to 2002. The goaltender had a stint in the NHL in 2001–2002 and had a 2.45 GAA and a 1-3 record in six games.

ROB PATTISON, LEFT WING. Pattison had 61 points, 37 goals, and 48 PIM in 106 games during his three seasons with Albany (1995 to 1997 and 1998–1999). He also played in the AHL with Adirondack in 1997–1998 and spent time in the ECHL between 1995 and 1999 and the IHL in 1997–1998.

JOSH DEWOLF, DEFENSE. In his three seasons with the River Rats from 1997 to 2000, DeWolf had 32 points, 28 assists, and 149 PIM in 135 games. He also spent time in the AHL with Quebec from 1999 to 2001, Cincinnati from 2001 to 2003, and Houston in the 2003-2004 season.

MIKE RUPP, CENTER. He accumulated 227 PIM, 69 points, and 38 assists in 196 games during his three seasons with Albany from 2000 to 2003. Rupp was the New York Islanders' number-one pick (No. 9 overall) in the 1998 NHL entry draft. In his three NHL campaigns between 2002 and 2006, the center had 26 points, 15 goals, and 126 PIM in 123 games. Rupp skated with 2002–2003 Stanley Cup–winning New Jersey.

ALEXANDER SEMAK, CENTER. A veteran of six NHL seasons from 1991 to 1997, Semak produced 174 points and 83 goals in 289 games. In the 1998–1999 season with the River Rats, he registered 62 points and 42 assists in 70 games. The center also skated in the AHL with Utica in 1991–1992 and Syracuse in 1996–1997. Semak spent time in the IHL from 1996 to 1998 and was named the IHL's playoff MVP in 1997–1998 with Turner Cup–winning Chicago.

PETER SIDORKIEWICZ, GOALIE. He earned the most wins (77) and the most shutouts (8) and played the second most games between the pipes (152) in River Rats history. Sidorkiewicz posted a 77-52-18 record and a 3.01 GAA during his four seasons with Albany (1993–1994 and 1995 to 1998). In eight NHL seasons between 1987 and 1998, the goaltender compiled a 3.60 GAA and a 79-128-27 record in 246 games. Sidorkiewicz also set single-season River Rat records for games in goal (62) and wins (31) in 1996–1997.

PETR SYKORA, RIGHT WING. Sykora was New Jersey's number-one draft pick (No. 18 overall) of the 1995 NHL entry draft and a member of the Devil's Stanley Cup–winning team in 1999–2000. In 10 NHL seasons between 1995 and 2006, the right-winger generated 512 points and 225 goals in 682 games. Sykora skated in three campaigns with the River Rats from 1995 to 1998 and registered 55 points and 28 goals in 50 games.

PIERRE DAGENAIS, LEFT WING. Dagenais is tied for 4th in goals (86) and is 10th all-time in points (159) in River Rats history. He also had 138 PIM in 224 games during his four seasons with Albany from 1998 to 2002. The left-winger skated in five NHL seasons between 2000 and 2006 and compiled 58 points, 35 goals, and 58 PIM in 142 games.

FREDERIC HENRY, GOALIE. Henry was between the pipes for six seasons with Albany from 1996 to 2002, earned a 3.15 GAA, and had a 44-52-10 record in 127 games. He also spent time in the ECHL between 1997 and 2002 and the UHL in 2001–2002.

SERGEI VYSHEDKEVICH, DEFENSE. Vyshedkevich had 112 points, 81 assists, and 56 PIM in 198 games during his three seasons with Albany from 1996 to 1999. The defenseman appeared in two NHL seasons from 1999 to 2001 and had seven points, five assists, and 16 PIM in 30 games.

ERIC BERTRAND, LEFT WING. The left-winger is tied for fourth all-time in goals (86), sixth all-time in points (186), and eighth all-time in assists (100) in River Rats history. In his four seasons with the club from 1995 to 1999, Bertrand also had 819 PIM in 301 games. He played in 15 games and registered four PIM during his two NHL campaigns from 1999 to 2001.

SASHA LAKOVIC, LEFT WING. Lakovic skated with the River Rats for three seasons from 1997 to 2000 and amassed 395 PIM, 41 points, and 23 assists in 91 games. During his three years in the NHL from 1996 to 1999, the left-winger garnered 118 PIM and 4 points in 37 games. He also skated in the CHL, CoHL, ECHL, IHL, and the WCHL.

TED DRURY, CENTER. A member of the U.S. National Team in 1991–1992 and 1993–1994, Drury generated 18 points, 10 assists, and 23 PIM in 51 games during his only season with the River Rats in 2001–2002. In his eight NHL seasons from 1993 to 2001, the center contributed 93 points, 41 goals, and 367 PIM in 414 games.

JAY PANDOLFO, LEFT WING. In his three seasons with the River Rats from 1995 to 1998, the left-winger had 53 points, 29 assists, and 24 PIM in 68 games. A member of two Stanley Cup–winning teams with New Jersey in 1999–2000 and 2002–2003, Pandolfo garnered 153 points, 88 assists, and 108 PIM in 570 games during his nine seasons with the Devils (NHL) between 1996 and 2006.

SASCHA GOC, DEFENSE. Goc registered 88 points, 68 assists, and 120 PIM in 184 games during his four seasons with the River Rats from 1998 to 2002. The defenseman was in the NHL for 22 games while playing with New Jersey from 2000 to 2002 and Tampa Bay in 2001–2002. He also skated in the AHL with Springfield in 2001–2002.

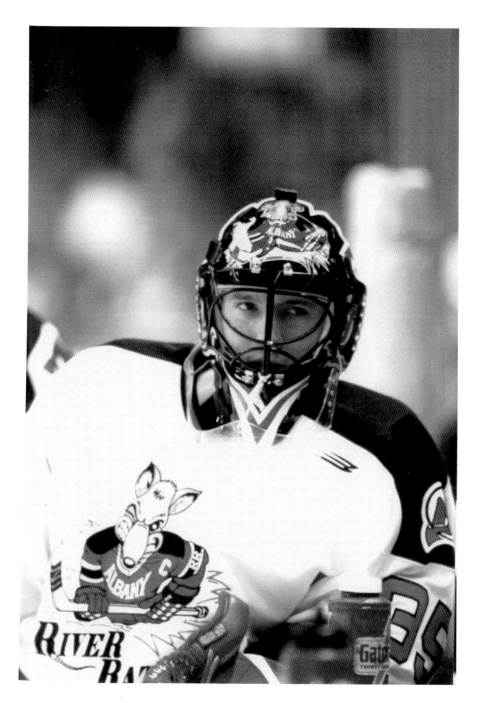

RICHARD SHULMISTRA, GOALIE. Shulmistra has the lowest all-time career GAA (2.53) in River Rats history. The goalie also compiled a 31-21-6 record in 70 games during his three seasons with Albany from 1996 to 1999. In his two stints in the NHL in 1997–1998 and 1999–2000, he earned a 1.48 GAA and a 1-1-0 record in two games. Shulmistra also holds the single-season GAA record (2.31) for Albany, which he set in 1997–1998.

DISCOVER THOUSANDS OF LOCAL HISTORY BOOKS FEATURING MILLIONS OF VINTAGE IMAGES

Arcadia Publishing, the leading local history publisher in the United States, is committed to making history accessible and meaningful through publishing books that celebrate and preserve the heritage of America's people and places.

Find more books like this at
www.arcadiapublishing.com

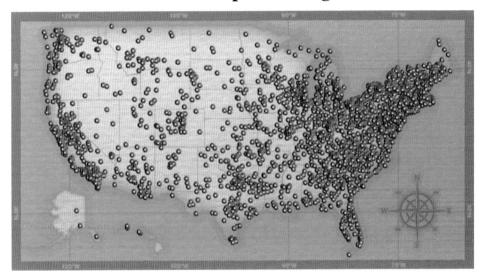

Search for your hometown history, your old stomping grounds, and even your favorite sports team.